photographing
Washington

Where to Find Perfect Shots and How to Take Them

Gordon and
Cathie Sullivan

THE COUNTRYMAN PRESS
WOODSTOCK, VERMONT

Maps by Paul Woodward, © The Countryman Press
Book design and composition by S. E. Livingston

Photographing Washington
978-1-58157-205-6

Published by The Countryman Press,
P.O. Box 748, Woodstock, VT 05091

Distributed by W. W. Norton & Company, Inc.,
500 Fifth Avenue, New York, NY 10110

Printed in the United States of America

10 9 8 7 6 5 4 3 2 1

Opposite: Waves are enhanced when shot from a high angle
with slow shutter speed and a polarized sky.

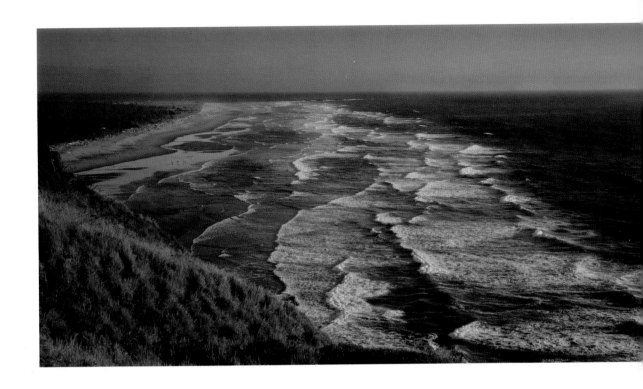

We would like to thank the good folks at Countryman Press and W. W. Norton,
whose dedication and individual talents helped make this book a reality.

Cathie and I wish to dedicate this book to our children, William, Amanda, Ryan, and Riley.
One and all, they have grown up and lived in naturally beautiful places.
We hope that as they turn the pages of this book, they will see just how much
we love the natural world and wish the same for them.
Life is short, so get out and breathe the air in some quiet place
where memories are made.

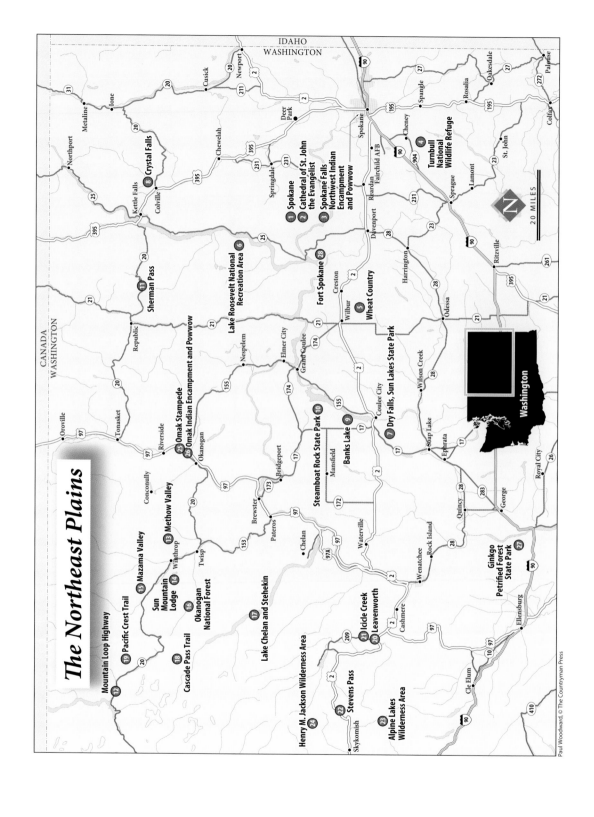

The Northeast Plains

Mountain Loop Highway ⑫
⑲ Pacific Crest Trail
⑮ Mazama Valley
⑬ Methow Valley
Sun Mountain Lodge ⑭
⑯ Okanogan National Forest
⑱ Cascade Pass Trail
⑰ Lake Chelan and Stehekin
Henry M. Jackson Wilderness Area ㉔
⑳ Stevens Pass ㉒
Alpine Lakes Wilderness Area ㉓
㉑ Icicle Creek
⑳ Leavenworth

Ginkgo Petrified Forest State Park ㉗

⑫

Omak Stampede ㉕
⑥ Omak Indian Encampment and Powwow
⑪ Sherman Pass
⑥ Lake Roosevelt National Recreation Area
⑧ Crystal Falls
Fort Spokane ㉘
⑤ Wheat Country
Steamboat Rock State Park ⑩
Banks Lake ⑨
⑦ Dry Falls, Sun Lakes State Park

① Spokane
② Cathedral of St. John the Evangelist
③ Spokane Falls Northwest Indian Encampment and Powwow
④ Turnbull National Wildlife Refuge

CANADA
WASHINGTON

IDAHO
WASHINGTON

Washington

N

20 MILES

Paul Woodward, © The Countryman Press

The Southeast Columbia Plateau

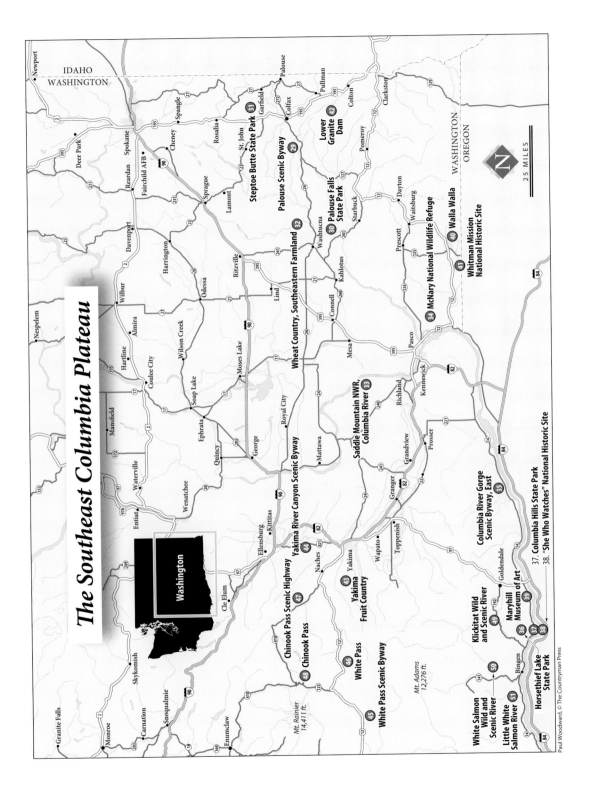

Washington

25 MILES

31 Steptoe Butte State Park
29 Palouse Scenic Byway
42 Lower Granite Dam
30 Palouse Falls State Park
32 Wheat Country, Southeastern Farmland
34 McNary National Wildlife Refuge
40 Walla Walla
41 Whitman Mission National Historic Site
33 Saddle Mountain NWR, Columbia River
44 Yakima River Canyon Scenic Byway
47 Chinook Pass Scenic Highway
48 Chinook Pass
43 Yakima Fruit Country
46 White Pass
45 White Pass Scenic Byway
35 Columbia River Gorge Scenic Byway, East
37. Columbia Hills State Park
38. "She Who Watches" National Historic Site
49 Klickitat Wild and Scenic River
36 Maryhill Museum of Art
50 White Salmon Wild and Scenic River
51 Little White Salmon River
39 Horsethief Lake State Park

Mt. Rainier 14,411 ft.
Mt. Adams 12,276 ft.

Paul Woodward, © The Countryman Press

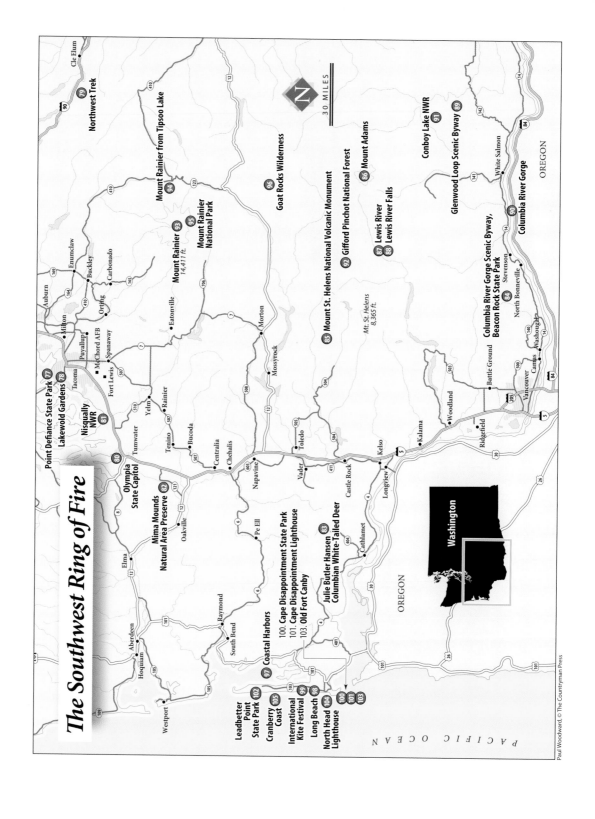

The Southwest Ring of Fire

Washington

OREGON

PACIFIC OCEAN

77 Point Defiance State Park
78 Lakewold Gardens
81 Nisqually NWR
80 Olympia State Capitol
82 Mima Mounds Natural Area Preserve
83 Julie Butler Hansen Columbian White-Tailed Deer
97 Coastal Harbors
 100. Cape Disappointment State Park
 101. Cape Disappointment Lighthouse
 103. Old Fort Canby
102 Leadbetter Point State Park
105 Cranberry Coast
99 International Kite Festival
98 Long Beach
104 North Head Lighthouse

79 Northwest Trek

Mount Rainier from Tipsoo Lake
94 Mount Rainier 14,411 ft.
93 **95** Mount Rainier National Park
96 Goat Rocks Wilderness
85 Mount St. Helens National Volcanic Monument
Mt. St. Helens 8,365 ft.
92 Gifford Pinchot National Forest
86 Mount Adams
87 Lewis River
88 Lewis River Falls
89 Conboy Lake NWR
91 Glenwood Loop Scenic Byway
90 Columbia River Gorge
94 Columbia River Gorge Scenic Byway, Beacon Rock State Park

OREGON

30 MILES

Cle Elum
Enumclaw
Buckley
Carbonado
Auburn
Milton
Puyallup
Tacoma
McChord AFB
Fort Lewis
Spanaway
Orting
Eatonville
Rainier
Yelm
Tumwater
Tenino
Bucoda
Centralia
Chehalis
Napavine
Morton
Mossyrock
Toledo
Vader
Castle Rock
Longview
Kelso
Kalama
Woodland
Ridgefield
Battle Ground
Vancouver
Camas
Washougal
North Bonneville
Stevenson
White Salmon
Oakville
Pe Ell
Raymond
South Bend
Elma
Aberdeen
Hoquiam
Westport

Paul Woodward, © The Countryman Press

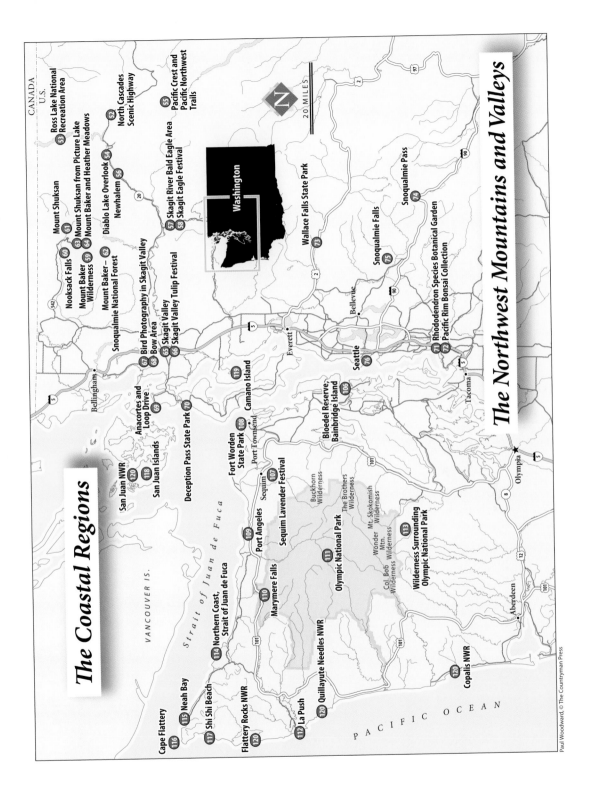

The Coastal Regions

The Northwest Mountains and Valleys

CANADA
U.S.

53 Ross Lake National Recreation Area

61 Mount Shuksan

63 Mount Shuksan from Picture Lake

64 Mount Baker and Heather Meadows

52 North Cascades Scenic Highway

54 Diablo Lake Overlook

56 Newhalem

55 Pacific Crest and Pacific Northwest Trails

50 Nooksack Falls

60 Mount Baker Wilderness

59 Mount Baker Wilderness

62 Mount Baker – Snoqualmie National Forest

67 Bird Photography in Skagit Valley

68 Bow Area

65 Skagit Valley

66 Skagit Valley Tulip Festival

57 Skagit River Bald Eagle Area

58 Skagit Eagle Festival

Washington

73 Wallace Falls State Park

75 Snoqualmie Falls

74 Snoqualmie Pass

71 Rhododendron Species Botanical Garden

72 Pacific Rim Bonsai Collection

Bellingham

69 Anacortes and Loop Drive

120 San Juan NWR

118 San Juan Islands

70 Deception Pass State Park

119 Camano Island

106 Bloedel Reserve, Bainbridge Island

76 Seattle

Everett

Belleuue

Tacoma

Olympia

108 Fort Worden State Park

Port Townsend

107 Sequim Lavender Festival

Sequim

109 Port Angeles

111 Olympic National Park

110 Marymere Falls

Buckhorn Wilderness

The Brothers Wilderness

Mt. Skokomish Wilderness

Wonder Mtn. Wilderness

Col. Bob Wilderness

113 Wilderness Surrounding Olympic National Park

Aberdeen

114 Northern Coast, Strait of Juan de Fuca

VANCOUVER IS.

Strait of Juan de Fuca

Cape Flattery

116 Cape Flattery

115 Neah Bay

117 Shi Shi Beach

Flattery Rocks NWR

120 Flattery Rocks NWR

112 La Push

120 Quillayute Needles NWR

120 Copalis NWR

PACIFIC OCEAN

N

20 MILES

Paul Woodward, © The Countryman Press

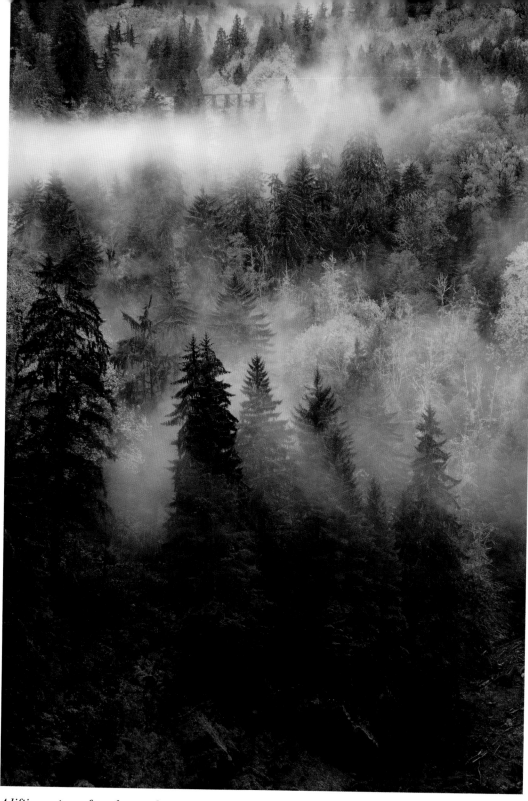

A lifting autumn fog enhances the scene.

Contents

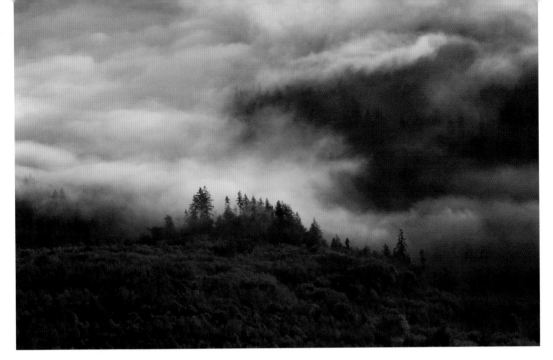

Sunrise on Hurricane Ridge.

Introduction

A heavy fog clung to the valley that morning on Washington's Olympic Peninsula as Cathie and I anxiously waited for something exceptional to happen. We had been there before to photograph the sunrise, but still we fidgeted as if it were our first time. Sitting there sipping coffee in the cool morning air, I began to think about the countless number of times we'd waited at spectacular settings like this, settings dispersed between our home in Montana, a myriad of canyons throughout the Southwest, and onward to more distant locales like Hawaii's Napali Coast. When a faint but promising glow began to appear in the sky, my mind returned to Hurricane Ridge, where we waited on this occasion. And within just a few minutes, another day of photography had begun.

If you're like us, waiting in beautiful places is second nature. It is part of who we are and what we do as nature photographers, one of those necessary requirements, the dues we pay, so to speak, for the wonderful images we capture with our cameras. This waiting no doubt serves a purpose in our photographic lives. It slows us down, and more or less forces us to recall other times, other places, other images. Waiting helps remind us of the important reason we're here in the first place: a love of nature. In the end, time spent waiting helps us grasp the exciting possibility that somewhere, someone will see one of our images and, possibly for the first time, realize how important it is to protect what remains of the natural world around us. Make no mistake about it, beautiful images, of beautiful places, inspire great things in the human mind. Whether you are aware of

it or not, your creative work as a nature photographer may well serve as a catalyst for environmental progress somewhere down the line.

That morning on Hurricane Ridge, and other mornings like it, this understanding lent us a sense of purpose as we waited, the tangerine glow on the horizon steadily increasing until suddenly the morning sun burst through, painting a brilliant blush across the fog-carpeted valley below—and the waiting was over.

Chances are you, too, have a long list of waiting places, sunrise moments, when things are taking shape. If you enjoy nature photography as much as Cathie and I do, you can't help but form special attachments, special memories of special places. In *Photographing Washington,* we hope to add to that list. Our goal is to guide you to some of the remarkable places and sites that make up our cherished memories. They are places we return to, time and time again, to create great photographs.

That morning on Hurricane Ridge turned special with the rising of the sun as bright light spread across the fog-topped valley. As usual, Cathie went her way and I, mine, as our cameras captured shot after shot. And just as quickly as the right moment had arrived, it was over. We put our cameras aside and rested on huge rocks as the morning brightened and other photographers joined us on the ridge.

During our extensive careers, Cathie and I have benefited from a closely knit community of nature photographers. Rarely in our travels do we come across a photographer not willing to divulge a favorite place or special tip, or to share the story of their last adventure in some spot not yet introduced on the cover of a travel magazine. Nature photographers are linked to one another by beautiful places, painterly light, and the joy that we receive from our art. *Photographing Washington* is our most recent contribution to that fruitful exchange, and we look forward to sharing it with you.

The Lure of Washington

Borders, those invisible lines of separation capriciously drawn between individual states, play an important role in our history as a nation. As they stand, most borders have more to do with geopolitical matters and human assumption than such criteria as geography, climate, flora and fauna, river systems, geology, forest types, or even culture.

Had its natural features figured prominently in determining its dividing lines, then certainly Washington, with all its immense diversity, so dissimilar from north to south and east to west, would be many states, not just one.

This vast, beautiful region, with its craggy mountain ranges, wide-open plains channeled to bedrock by titanic floods, volcanoes, lush rainforests, rock-rimmed coasts, sandy beaches, and outlying islands, is truly a natural wonder. By any standard, it is a photographer's Eden.

In addition to its three national parks—Olympic, Rainier, and North Cascades—Washington is home to Mount St. Helens National Volcanic Monument, three distinct Wild and Scenic Rivers, 7 national forests blanketing a massive 8.5 million acres, 20 wildlife refuges, a host of federally designated wilderness areas, and a staggering 186 state parks. Washington has sandy and rocky beaches snaking for hundreds of miles along its west coast, all wild and rich in character. And then there are the charming islands, spits, peninsulas, and protected harbors, in many cases separating Washington's mainland from the Pacific Ocean by 80 miles or more.

As you might imagine, the state's tremendous natural beauty draws a great many outdoor recreationists. Visit the area and you'll find that almost everyone around you is heading somewhere, going camping, mountain climbing, beachcombing, kite flying, or, like us,

lured by the promise of outdoor photography. Not only does Washington have natural attractions worth a king's ransom, there is always something interesting going on—a small-town rodeo, a tulip festival, a farmers' market, clambake, or wine tasting—the list is virtually endless and the diversity remarkable.

No place Cathie and I have visited comes close to Washington in terms of the photographic opportunities that await here. As a matter of fact, it could take several lifetimes to exhaust just one season's list of possible images, much less an entire year's. From a photographer's perspective, however, the change of seasons is mesmerizing, offering the opportunity to cross yet another capricious border. While I like the vibrant colors and chill of autumn, Cathie prefers summer, when colorful kites streak across the sky, the scent of lavender permeates the air, and beaches radiate in the glow of the setting sun. While I like the high mountains, she prefers the cool, moist rainforests. While I find interest on the eastern channeled scablands, she dreams of whales breaching just off the coast. That's something else Washington does for photographers: it helps define what among the many things around us holds the real interest for us as artists.

It might seem cliché to say that Washington is many things to many people, but this is in fact true, and the senses are stimulated by all you have to choose from here.

As fellow artists, we invite you along on a photographic tour of Washington, one of our special places.

Washington's Human Saga

It is possible that humans had already arrived in Washington by the time the first ice age floods swept through the eastern plains, carrying an amazing 500 square miles of water. The early immigrants were hunter-gatherers who had come to the North American continent by way

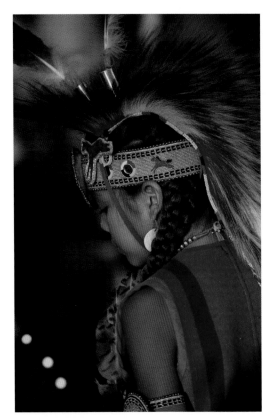

A 200mm lens and high ISO allows for an intimate look into Native American life.

of a land bridge opened on the Bering Sea. The wanderers followed herd animals south through ice-free corridors just east of the coastal mountains. Little did these newcomers know that they had discovered a land of plenty nourished by both the sea and surrounding forests. For those who followed, the vast bounty of the Pacific Ocean offered a mainstay. Russian, English, and Spanish ships ventured into the area early, and by the time the Corps of Discovery, led by Meriwether Lewis and William Clark, arrived in the early 1800s, the indigenous population was already in serious decline due to disease and war brought by foreigners.

It's been mostly the bounty of the sea and surrounding forests that has since fueled the

prosperity of the coastal regions of Washington; a bounty that in later years included trade, mining, and of course more fishing.

Driven by progress, the coastal areas of Washington were settled first, with water routes serving as the primary means of travel. Sufficient roads came in the 1900s, followed by the railroad. The spread of human occupation followed, first along the coast and later inland to the base of the mountains. The vast, arid eastern regions of the state had to wait for improved roadways and railroads, but gradually they came, and stouthearted individuals followed. The 1930s brought the damming of great rivers across the face of America's western landscape. In the eyes of many, it was this wave of progress that once and for all opened the eastern plains to progress. As it did, however, it changed the lives and culture of Native people once totally reliant on the magnificent Pacific salmon runs.

Today you'll find western Washington bursting with people, while the eastern two-thirds of the state remain sparsely populated in comparison. Throughout Washington, however, you'll find the strong thread of human history, well-anchored by a sense of place uncommonly different from east to west. Of all the things that promote lifestyle and cultural difference between eastern and western Washington, climate is perhaps the most profound. Those in the west adapt on a daily basis to extremely moist weather from the Pacific, a factor of the precipitous rise of the Cascade Range. Life east of the mountains seems a constant struggle for moisture, eased in some places by irrigation from mighty rivers like the Columbia and Snake.

The two distinct sides of Washington have fostered two unique cultures, the fingerprints of each pressed firmly into a rich and rugged landscape.

Remnants of the past tell a story on the plains.

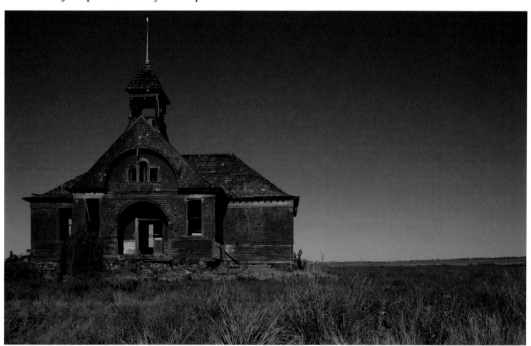

How to Use This Book

With this book, we hope to accompany you as you adventure, camera in hand, through the magnificent state of Washington. While directing you toward the most rewarding photographic sites, we also seek to share with you valuable information about photographic techniques and composition, as well as useful field tricks we've learned in our careers as professional photographers.

For convenience, in our photographic tour of Washington we divide the state into five distinct sections. Within each section, we identify a number of great sites where photographic opportunities await. The selected sites represent places we oftentimes rely on as professional nature photographers, places that have special appeal as well as being in demand in today's image market. In choosing the sites, our emphasis was on natural beauty and cultural and historical significance.

In dividing the state east to west, we use a special line of demarcation, the fabulous Pacific Crest Trail. For a north-south division we use Interstate 90, and for the final section, Washington's coastal regions, we use the rugged Pacific Coast from the Canadian border to Oregon, and we also include a large chunk of land and coast located southwest of Olympic National Park.

Included in our site descriptions are suggestions about the best time to arrive at special places; what time of day we prefer to be at work at certain locations; what seasons work best; what climatic conditions might be present or worth waiting for; and what special equipment might be useful; among other practical considerations, to optimize your visits to these locations.

Most of the sites are on well-maintained

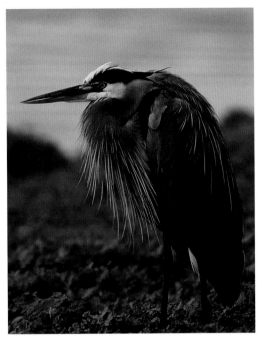

Blue herons are denizens of the state.

roads, gravel or paved, or are a short day-hike from a road (5 miles or less). There are some exceptions, including some wilderness areas and Wild and Scenic Rivers such as White Salmon and Klickitat Rivers, national monuments, and a few national wildlife refuges like Saddle Mountain. Detailed maps are included for each section, and sites are numbered and named for easy reference.

Information intended to aid you in your photographic journey is presented in three locations in the book: in the front material, within the short description presented for each site, and in the captions accompanying the photographs, which describe the special factors at work in each image.

Each photograph included here is meant

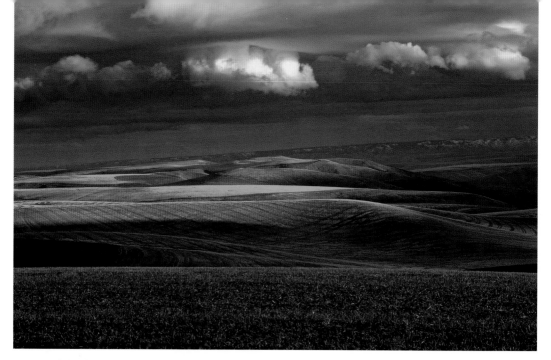

Low-angle light just before sunset adds dimension and drama to a southeastern landscape image.

to accomplish two things: First, it identifies a specific subject associated with the site, and second, it demonstrates technique, the use of special equipment such as filters, and light sources and exposure information. Captions are intended to be educational source material; we encourage readers to take special note of the information contained there.

Throughout our career as nature photographers we have learned to rely on National Wildlife Refuges we encounter along the way as sites for both landscapes and wildlife images. Since these sites are primarily established for the protection and proliferation of wild species, they are not necessarily located in strikingly picturesque places. The refuges we include here are identified as either exclusively wildlife spots or good for both wildlife and landscape.

For many of the sites we have selected for *Photographing Washington,* certain permits are necessary, either a Washington State Discover Pass, a National Forest Recreation permit, or a Tribal Recreation permit. If you are planning to photograph a site, a few minutes of research on the Internet or a simple phone call will clue you in to any necessary permits or fees. Contact information is given at the end of each site description. For events like rodeos, Indian powwows, and festivals, make sure to contact event officials for information or restrictions. Event officials are very helpful and enjoy having serious photographers work their events.

Each section in the book includes a brief introduction discussing geographic setting, geology, climate, and the historical and cultural influence of the region. We believe that the more you know about an area, the more inspired your photographs will be. The introductions cover basic information and are intended as a starting point. We strongly advise you to learn as much as you can about your chosen subjects before you set out to photograph them.

How We Photograph Washington

Special Considerations

For the purposes of this book, it doesn't matter what kind of camera you own, high-end digital or point-and-shoot. It doesn't matter if you have elected to stay with film as opposed to digital. What does matter is where you point your camera, how you approach your subject, and what compositional elements you include in the finished picture—and, of course, the light you use. Photography, from our perspective, is an art, and has far more to do with a photographer's artistic ability than it does expensive equipment, gadgetry, or even notable subject matter. On a similar note, successful images, the ones that truly grab the viewer's eye, express emotion or mood, not merely record interesting events or exceptional vistas. In the end, creating powerful images takes creative vision combined with proven technique and experience. Understanding the basic guidelines of composition combined with important technical components like light, motion, contrast, color, depth of field, and dynamic range are all important.

Even in a remarkable state like Washington, where seemingly everywhere you look, a great picture awaits, capturing sublime images depends not only on finding suitable locations but on making them work for you.

It might seem complicated to get everything right in the beginning, but a few minutes spent on the basics will help greatly. We start our creative voyage with light, the photographer's paintbrush.

Light

Among all the natural elements available to photographers, light and the use of light is

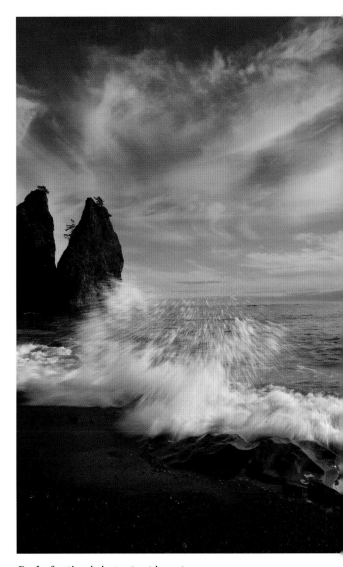

Peak of action is important in nature.

prime. The better we understand light and its effect on the world around us, the better our images. It doesn't matter if the light is natural or artificial; what matters is how it illuminates a subject, where it falls on a scene, and, in the

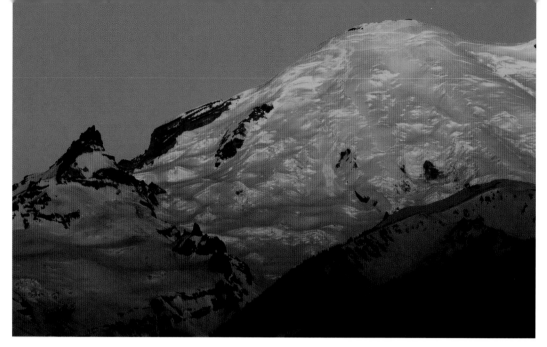

Alpenglow on Mount Rainier.

end, what emotion it evokes. Photographers experience a gamut of natural light as they work to capture Washington subjects ranging from panoramic landscapes to intimate close-ups. How we use light determines the emotional effect our images have on viewers. Again, as you study the images in this book, pay special attention to the visual effect different light sources have on each shot. Pay attention to where light enters the scene, what color it casts, and how it illuminates the various subjects.

Sidelight

Sidelight enters the scene from left or right of camera position. It effectively rakes across the scene, heightening contrast while lengthening shadows large and small. It is a good choice for most landscapes because it adds depth and texture to large subjects such as mountains, seascapes, and open vistas like those found on Washington's eastern plains. Sidelight is particularly useful early and late in the day, when the sun's low angle emits an amber or flaxen hue. The lower the sun is in the sky, the more dramatic the effect.

Front Light

This light comes from directly behind the camera, over the photographer's shoulder. Because it illuminates subjects head-on, it extends shadows directly behind, hiding them from view. The absence of distinct shadows oftentimes makes front light appear flat. Try taking a few steps to either side, quartering the light slightly, and allowing small shadows to appear.

For colorful subjects, however, front light can be useful, especially when it originates lower in the sky. The higher the sun climbs approaching midday, the less interesting it becomes. Among the best times to rely on strong front light is, again, early in the morning or late in the day, when it emits warmth and intensity.

Notably, front light also creates "alpenglow," that beautiful ruby blush first appearing on high mountains like Mount Rainier, Shuksan, and others just prior to dawn.

Backlight

Avoided by many nature photographers, backlight is perhaps the least understood, albeit most dramatic, light source in nature.

Coming directly into the camera lens, backlight creates a sense of intrigue. It radiates through translucent subjects like maple leaves, forest canopies, grass, heavy mist, water, and clouds, where it can convey a sense of power and bold elegance when used effectively. It is particularly useful for early and late seascapes that include moving water, active waves, and bold offshore landforms.

In the case of some translucent subjects like water and leaves, a telephoto lens can be used to isolate individual elements of a scene set aglow by backlight.

Soft or Diffused Light

In the twentieth century, landscape photography was heavily influenced by master photographer Eliot Porter and his signature use of soft or diffused light.

This light source ranks among our personal favorites, especially in Washington, where many mornings are graced with heavy mist, valley fog, or low-hanging clouds.

Soft light results from overcast or misty skies, open shade, or partial shade. For colorful subjects like autumn trees and bushes, streambeds, and somber mountain scenes, it can't be equaled. Because it illuminates with relatively even distribution, soft light diminishes contrast and harsh shadows, which can add chaos to detailed scenes like forests and streambeds. For bright colors, specifically those on the warm end of the spectrum, like red, yellow, orange, and green, soft light is very effective.

Typically imbued with high contrast and strong shadows, scenes like streambeds bordered by rocks, grass, and shrubs make perfect soft-light subjects. When shooting under high forest cover like that found in Olympic and North Cascades National Park and parts of the Columbia River Gorge, evenly dispersed soft light masters the day.

Artificial or Mixed Light

Artificial light is created electronically by tungsten or fluorescent lamps and can appear either outside or inside buildings or on street scenes. Most historic buildings and cityscapes

Soft or diffused light produces some of our favorite photographic effects.

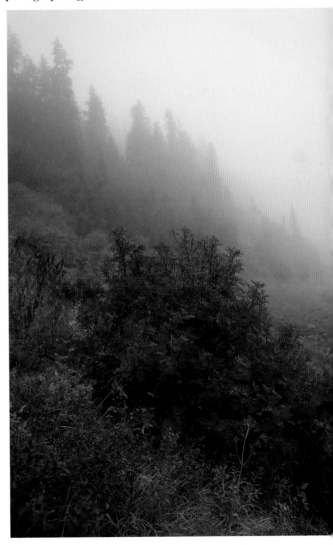

are lit artificially. When working with artificial light, a white-balance adjustment or filtration is required to compensate for the different color temperatures emitted by lamps. When shooting under artificial light, take special note of the white-balance adjustment necessary to compensate for or even create certain effects.

At times, artificial and natural light combine to provide illumination, or natural light might be filtered purposely through stained glass windows to create a wonderful visual effect.

Sunrise and Sunset

No discussion about light is complete without considering the high drama of sunrise and sunset, those rewarding times when mountains, rivers, lakes, open plains, and beaches boom with grandeur.

Washington skies often include clouds, fog, or mist, which serve as complimentary elements for great sunsets and sunrises. These climatic effects add interest and nuance to sunrise and sunset shots. When deciding on whether the sky is right, first look at the distant horizon and gauge if clouds or heavy fog will impede the sun's ability to burst through. Generally, if the sky right above the horizon is open, the clouds above will intensely reflect the rising or setting sun. If you examine great sunset and sunrise pictures closely, chances are their visual interest is achieved by means of a climatic element, and the point above the horizon is either open or semitransparent.

We have found over time that sunrise and sunset make better images if they are used as supporting elements in a much larger scene, such as an open beach, massive mountain, foggy valley, or meandering stream.

Creative use of foreground adds power and depth to this Olympic beach scene.

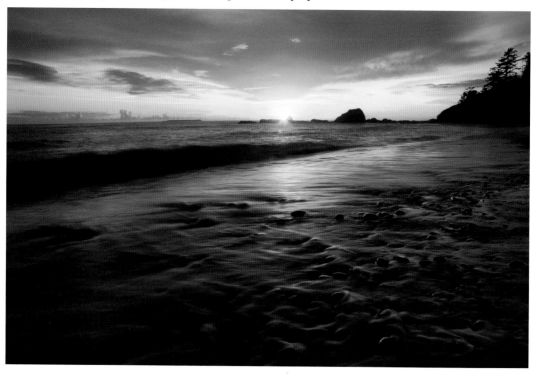

Composition and Technique

Master photographer Ansel Adams once said, "There is nothing worse than a sharp image of a fuzzy concept"—and he wasn't talking about camera focus. Instead, he was referring to photographic images that simply fail to evoke emotion or feeling, perhaps because the photographer paid no heed to the basic guidelines of composition.

Simply stated, composition can make or break a photograph, so before we focus our camera on the fantastic natural attractions of Washington, let's take some time to cover basic composition. Understanding a few important guidelines and knowing how and when to use them will help you create powerful imagery and make the most of beautiful settings.

One of the most elementary compositional guidelines is the rule of thirds, which is simple to understand and easy to implement. The rule deals with where to place your primary subject within a photographic rectangle. For greatest impact the subject should appear within one-third of the rectangle, either vertically or horizontally. To decide on placement, simply divide the camera's viewfinder into thirds, first horizontally and then vertically. Placing the primary subject at the intersection of those imaginary lines is most effective and leads to more pleasing composition and stronger images. What is most important is to avoid placing primary subjects dead center, a tendency among many beginning photographers. Remember, this is merely a guideline, not an absolute rule, but trust us, it works wonders in promoting balance and symmetry.

Another useful guideline sometimes overlooked by nature photographers is to keep it simple. Very often, particularly when composing large landscapes, photographers are tempted to include too much in the picture, thus weakening visual impact. To avoid un-

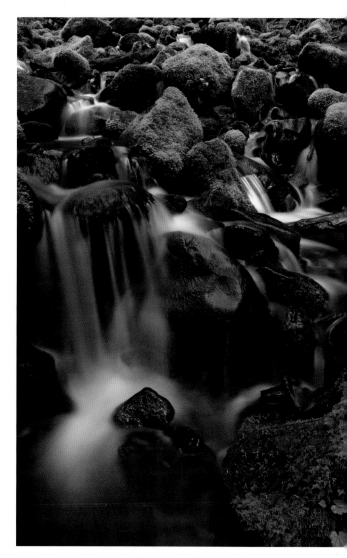

A slow shutter speed and tripod enabled this nice midrange shot of water and moss.

necessary elements creeping in, slow down a notch and ask yourself, "What attracted me to this scene in the first place?" Focus on only those strong elements that initially drew your attention. Avoid cluttering a good image with unnecessary and distracting features.

Another tip is to first photograph the larger scene and then concentrate on the most inter-

When composing your shots, ask, "What drew me to this scene in the first place?" Focus on those strong elements that attracted your attention.

esting elements inside the scene with a longer lens or change of position. We call it "dissecting a scene," isolating certain features that are themselves alluring—one small section of a waterfall, for example.

Using specific color to invoke feeling or emotion is another tool, especially if vivid colors make up the central theme of your subject or lead the viewer's eye toward it. Bright colors like red, orange, and yellow command attention, and when mixed with patches of black can depict power and mystery. More subtle colors like blue or green convey tranquility and well-being, while gold and russet speak to richness and depth. Incorporating these palettes into your photography deepens emotion while pushing the images to a higher artistic level.

Utilizing lines of sight in an image is another effective tool. Repeating vertical lines convey a sense of stalwartness and heft, while diagonal lines suggest flux. Horizontal lines like horizons can lend a sense of calm and stability, while bending lines such as S curves impart continuous motion or serenity. Such patterns can strengthen overall presentation. Learn to watch for them as you compose either large-scale landscapes or close-up images.

Some subjects require special technical considerations. When shooting flowing water, for instance, pay close attention to shutter speed. A slow shutter, a 15th of a second, for example, allows flowing water to blend, creating a sense of unimpeded motion. Faster shutter speeds (250 and above) freeze flowing water, creating a more refined or realistic image. Before you shoot, ask yourself exactly which mood is important to your final image.

For powerful landscapes, climatic components like clouds, fog, and mist are important compositional elements, and sometimes

should even be cast center stage. Washington is blessed with wonderful weather conditions originating over the Pacific Ocean which add a great deal to strong landscapes. Breaking storms, valley fog, and morning mist are among the most impressive. As you incorporate them in your landscape photographs, take special note of unusual lines, patterns, or formations inside the clouds. Use them to embellish or mirror the terrain below.

Backlit fog, especially in morning, is another common occurrence in Washington, and brings high drama to images including mountains, rugged coastlines, and rolling farmland. Using backlit fog as a creative component can instantly turn a good image into a great image.

Heavy morning overcast is another repeating theme in Washington coastal regions and mountains. Used to your benefit, heavy overcast can add much to a scene. After all, it diffuses light and lowers contrast while allowing colors like green, yellow, and red to saturate. Cape scenes are a good example, where diffused light adds interest to the image by decreasing contrast and allowing for a much slower shutter speed to accent moving water. What you might want to do, however, is include only a small section of gray sky as opposed to emphasizing it.

Seeing Deeply

One way to avoid the fuzzy concept that Ansel Adams talked about is to previsualize images before investing time to photograph them. The question "What exactly attracts me to this scene?" goes to the heart of previsualization. Answering it, then using solid technique and selecting strong compositional elements, will set your work apart. The primary thing you want to evoke in your viewers is emotion, and this challenge starts at the point you are first attracted to a scene, large or small. Actually, that attraction itself is the result of your emotional response, pulling you in to a scene. Your job as a creative photographer is to pass on that emotion to viewers. There is nothing more rewarding in photography than to have a viewer experience the same sense of emotion that drew you, the artist, to a scene.

Finding Remarkable Images

Over our career as professional outdoor photographers we have had the opportunity to talk to many amateur photographers with years of experience as well as those just getting started with photography. A common theme we find among enthusiasts is a propensity to concentrate too heavily on iconic images, and thus to miss a host of wonderful photographic subjects along the way. Some of the images we get the most calls for professionally are those in which recognizable scenes of note are secondary: a stream raging at the foot of a famous mountain, a small pocket of wildflowers set against a well-visited waterfall, or a rock set aglow at sunrise. It is not enough to concentrate on the larger, more recognizable scenes.

Look for individual elements that might make a notable photograph.

One of the most commonly asked questions we get is "How do you find remarkable images?" The answer is simple. Be alert to your surroundings, be in tune with where you are and what makes it special, and look for those individual elements that might make a notable photograph. Basically, push your creative eye to the limit.

Washington rodeos are a great place to practice peak of action.

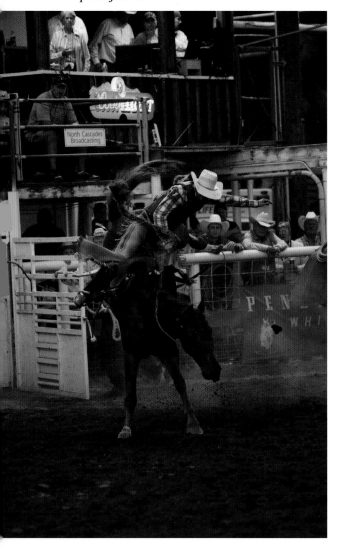

Developing Your Own Artistic Style

Another temptation for landscape photographers is to attempt to duplicate favorite images. Nature changes on a momentary basis, and what was true of the light and other conditions yesterday will certainly be different tomorrow, so don't try to duplicate images—better them. Bring fresh eyes to your locations, and once on the scene, apply your own creative vision to a subject and utilize those techniques that will put your own personal stamp on your shots.

Peak of Action

Whether you are an aspiring wildlife photographer or someone who just enjoys shooting action, one of the foremost challenges you will face as a photographer is capturing images at the very peak of action, that fleeting moment when everything comes together for a great picture. Let's say for example you're at a rodeo shooting bucking horses. The momentum builds and builds until finally reaching a pinnacle of action. It is then that elements like power, movement, speed, and color come together. That's when you trip the shutter. That is peak of action. A basketball player going in for a lay-up? The very second the ball leaves the athlete's fingertips at full extension is peak of action. Learning to predict it takes time, focus, and practice but it's a blast when you pick it up. A number of action shots in this book demonstrate peak of action.

Learning by Doing

A long time ago, we realized that if we were to successfully pursue nature photography as a profession, we had to continue to learn with each outing and work very hard to develop a unique style of shooting. What worked for us during those years was to study different tech-

niques and try them in the field. What we liked, we used; the rest we set aside. We always took the advice of other professionals and tested that advice in the field. Again we incorporated into our practice those things that worked for us and set aside the rest.

Equipment

Camera

In today's world, digital technology has all but taken over. Throughout our professional careers, Cathie and I have lugged around an assortment of equipment and camera formats ranging from 35mm SLRs to an impeccably sharp 4x5 Linhof. From our perspective, we've seen it all, and have steadily made the transition to digital without regret. For nature work we rely on Nikons and Cannons equipped with full-frame sensors and high megapixels for maximum resolution and file size. Once in the digital darkroom, we turn to a number of software programs including Photoshop CS5. Our field philosophy, however, hasn't changed from the old film days. In our view, a successful image is made in the field; one cannot and should not rely on software techniques to give it life later. The better technique you employ in the field, the better the end result. It is that simple.

Even though today's digital equipment and software programs allow photographers greater flexibility over film cameras, we still consider equipment to be a supportive component in the creative process. Frankly, we both have become much better photographers with our commitment to digital, but what gives us a leg up, we believe, is the vast experience we've gained over more than 40 years in the field. With digital, it just seems we have more options available to us, allowing us to capture the natural world with wider scope and range, if you will.

Lastly, if you are shooting digital, keep cam-

Patterns of color and shadow are created by dominant backlight.

eras and lenses as clean and dust-free as possible. It is far less time-consuming to clean and protect your equipment, particularly zoom lenses, than to remove dust spots later.

Lenses

During our film days, we amassed hundreds of thousands of transparencies and relied on lenses ranging from 20mm wide-angle to 600mm telephoto. Then the most widely used lens fell between 20mm and 50mm. Today, as we learn more about digital imagery, we tend to frame nature on much wider terms and rely on lenses between 10mm and 300mm, with the most commonly used lenses falling between 12mm and 35mm wide-angle.

No doubt the change is the result of our reliance on stronger foreground subjects and a keener sense of increased dynamic range (tonal difference spread across an image or the distance from the closest point of critical focus to infinity). Another factor might be that as we have improved as photographers, we've relied

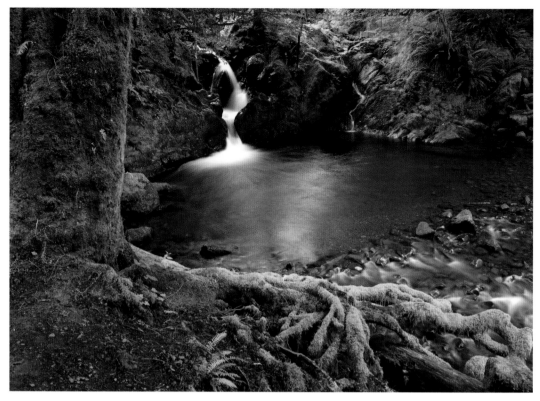

Using a tripod slows you down and leads to tighter compositions.

on much tighter composition and technique and as a result search harder for natural elements to support basic compositions.

Tripod

After a camera and lens, the most important piece of equipment in a photographer's possession is a sturdy tripod. Almost every nature image Cathie and I take begins on a tripod.

A tripod not only provides a solid base to eliminate camera movement, it significantly increases options and flexibility. Today, low-light shots emphasizing motion resulting from slower shutter speed comprise an impressive number of our cataloged images—and they would be impossible without a tripod. The same goes for the advanced technique of high dynamic range (HDR) requiring perfect registration from one exposure to another. As you study the images in this book, pay close attention to the shutter speed or ISO used to capture the shot, more solid evidence for a tripod.

Filters

Regardless of the assumption that similar coloration can be added during processing, we still rely on a few filters in the field, the foremost being polarizing, graduated neutral density, and continuous neutral density. We like to review results on the spot and make necessary adjustments when necessary. Call us old school, but years of field experience has taught us how to make necessary adjustments in the field, and we stick to those lessons.

The polarizing filter is one we never leave behind. Aside from creating deep blue skies,

it also eliminates glare from reflective surfaces like lakes, streambeds, snow, flower petals, leaves, and glacier-clad mountains. Another important use for a polarizing filter is to saturate warm colors like green, yellow, and red. This filter will also heighten rainbows either across a landscape or at the foot of a waterfall.

Graduated neutral-density filters are composed of clear glass with half the area darkened by shades of neutral gray to block out light. They are gauged in f-stops. By splitting the scene, these filters increase tonal range between light and dark areas. We use Tiffen large glass filters, which are attached to our lenses with Cokin holders. These compensate for tonal difference in one, two, and three f-stops. Say we are shooting a bright mountain and sky with a nice foreground which happens to be in shade. Metering both the mountain and foreground, we find two stops' difference. A two-stop neutral-density filter is the answer. With

the gray side placed on the bright portion of the image and the clear side on the shaded half, tonal range is extended by two f-stops, balancing the entire shot. While it is true we could create a similar tonality in the computer, we prefer to monitor the effect immediately.

Another filter we rely on is the continuous-neutral-density filter, which we use on some water shots to enhance the appearance of flow. This filter provides a continuous band of full neutral density from light to very dark, and allows a much slower shutter speed and enhanced flow.

With that basic foundation under us, it's time to venture out into the wonderful photographic world of Washington. We begin the adventure on the Northeast Plains and channeled scablands at Spokane, one of the state's largest cities. But first a few words about the origin of the interesting geography ahead of us.

A polarizing filter eliminates glare from reflective surfaces.

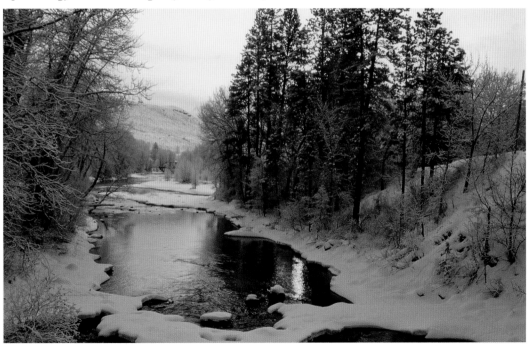

Hiking into wilderness takes time and effort but the images that result are ample reward.

I. The Northeast Plains

Photographing Washington's vast northeast landscape is the experience of a lifetime, especially when you consider the tremendous natural forces that combined eons ago to create this fractured landscape. Understanding the story will add greatly to your photography.

The entire setting you see before you, the open prairies, huge cliffs, and far-off mountains, actually came about by sheer happenstance. As a matter of fact, the entire landscape came from somewhere else, somewhere farther west.

Eons ago, our present North American continent drifted atop a much larger tectonic plate or megacontinent, which eventually broke apart. Riding on convection created deep inside the earth, each half traveled in different directions, with the ever-enlarging gap between filled by the Pacific Ocean. What is remarkable to us as visitors to today's northeastern Washington is that the west coast we know today was not created by the massive continental separation; the point of separation actually existed much farther east, on the western edge of Idaho and parts of Montana. The point of separation is known by experts as the Old West Coast.

So, what about the western lands we see before us? At one time, all of it, from the mountains to the scablands, existed as islands and terraces far off in Pacific waters. The same tremendous forces that split the old continent eventually forced these islands and terraces eastward, where they rammed the Old West Coast and eventually came to rest, becoming the present state of Washington. So tremendous was the collision between the newly arriving landforms, immense mountains wrinkled heavenward to become the Cascades, Okanogan Highlands, Selkirks, and others.

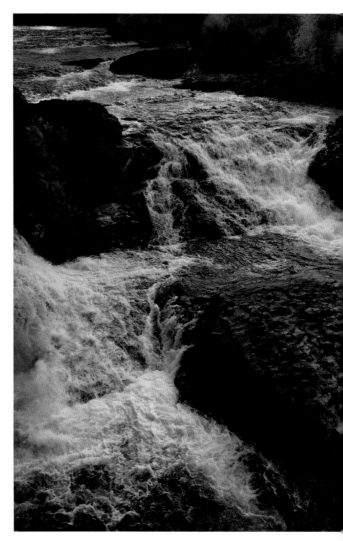

Spokane Falls thunders through Riverside Park.

In this remarkable way, the entire state of Washington came about. Serving as a poignant reminder of this great event, some of the names of the arriving landforms remain with us today: the Kootenay Arc, Intermountain Terraces, Shuksan Plate, and Okanogan Highlands.

The next catastrophic event that helped form the northeast landscape came as huge lava flows originating from massive cracks in the earth literally capped what we know today as the Columbia Plateau. The lava flowed as dark basalt and stretched from the Canadian border to deep inside Oregon. As amazing as it seems, experts believe the bedrock cracks

Manito Park is a spectacular site for photography in early autumn and summer.

through which the massive sheet of lava flowed were caused by an enormous meteorite from millions of miles away colliding with magnanimous force into the earth somewhere in southern Oregon. The impact was so great it fractured miles of deeply buried bedrock, releasing the molten lava. Clearly visible today are massive basalt cliffs and deep-lined valleys, the result of this catastrophic lava flow.

As if these events weren't enough, a third, more recent, calamity played a role in creating the landscape, the Glacial Lake Missoula floods. During the last ice age, which probably concluded between 8,000 to 10,000 years ago, a blink of the eye in geologic time, a huge lobe of ice moving in from Canada's Cordilleran Ice Sheet blocked the west-flowing Clark Fork River. The immense ice dam grew in size until it contained a staggering 500 cubic miles of glacial water. The dam finally ruptured, releasing tremendous floods, not once, but repeatedly throughout ice age. Some experts say every 50 to 100 years over this 2,000-year span, the dam broke, each time releasing floods carrying water in excess of all the world's rivers combined. The torrent raged across eastern Washington, scouring the land to the ancient basalt bedrock we witness today.

Its catastrophic origins left the landscape of the northeast region replete with wonderful photographic opportunity, and we begin our tour through this intriguing part of Washington at one of the state's largest cities, Spokane.

1. Spokane

Spokane and Tacoma generally compete for the bragging rights to be called Washington's second-largest city. With a population of approximately 200,000, Spokane has always been nothing less than a busy city with great aspirations, including winning its bid for the 1974 World's Fair. By all accounts, it is a town that generally relies on dreams to forge

its course; it became a railroad hub in the late 1800s despite being located more than 300 miles from the next major city. Over the years, as Spokane fulfilled its dreams, fortunes were made, and the present character of the town reflects that success.

Two locations we like to visit are **Spokane Falls,** located in Riverfront Park, almost in the heart of town, and beautiful **Manito Park**.

Located at 17th Avenue and Grand Boulevard, the 90-acre Manito Park includes several impressive gardens, including the Nishinomiya Japanese Garden, a formal rose garden, and a French Renaissance garden, all a pleasure to photograph. The park is open 4 AM–11 PM in summer and 5 AM–10 PM in winter.

Amazingly, Spokane Falls cascades 90 feet over rugged basalt cliffs virtually in the center of town. This impressive sight is a prime spot for photography as well as a fitting tribute to the magnificent power of nature thriving beside the hustle and bustle of city life.

Manito Park: www.manitopark.org;

Riverfront Park: www.spokaneriverfront park.com

2. Cathedral of St. John the Evangelist

This Gothic-style Episcopal cathedral is one of the most prominent sights on Spokane's South Hill, and a rewarding stop on any photographic tour. The cathedral's exterior includes a stately tower and wonderful stained glass windows, but it is inside that the true creative photography begins.

The subtle play of light filtering through stained glass creates a host of visual effects on ornate fixtures and alcoves. Ambient light inside the cathedral follows the outside movement of the sun as it crosses overhead—exactly the visual effect designers had in mind as the impressive building took form. The task at St. John's is to first establish white balance with-

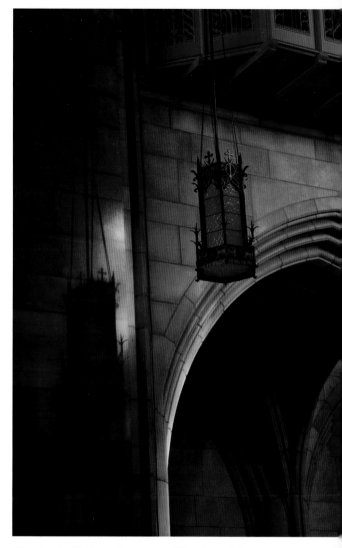

Fixtures inside the cathedral are illuminated by light filtered through stained glass.

out lessening the effect of outside light filtering through stained glass.

The cathedral is located at 127 East 12th Avenue, in Spokane. Tours are offered 12–3 Mon.–Thurs. and Sat. as well as Sun. after services.

Cathedral of St. John the Evangelist: 509-838-4277; www.stjohns-cathedral.org

3. Spokane Falls Northwest Indian Encampment and Powwow

During the final week of August each year, Native Americans from across the Northwest and points beyond gather alongside the spectacular Spokane River to celebrate traditional dancing, drumming, and Native dialect. If you haven't yet photographed a Native gathering, you are in for a treat. The festive colors, craft, and tradition are all sources of inspiration.

A few words of counsel before you get started: Talk to officials and inquire about specific guidelines for photography during the celebration. They are usually very helpful and willing to work with serious photographers.

American Indian Community Center, Spokane: 509-535-0886

Riverfront Park:
www.spokaneriverfrontpark.com

4. Turnbull National Wildlife Refuge

Situated on the eastern edge of the channeled scablands, 20 miles southwest of Spokane, Turnbull National Wildlife Refuge features a combination of wetlands, forests, and steppe environments, each providing habitat for an unusual number of wild species. The rugged terrain surrounding the refuge was carved by ice age floods and provides a suitable home for coyote, elk, deer, moose, 27 kinds of ducks, and a long list of smaller birds.

Turnbull is an awesome place to roam with camera in hand, and begins with a 5.5-mile loop open to cars, bicycles, and hikers. Open from dusk to dawn year-round, it is a great spot for both wildlife and landscape photography. Our favorite time of year there is October. There is a $3 per-car fee.

The refuge is located at 26010 South Smith Road, Cheney: from I-90 west of Spokane take WA 904 to Cheney, then turn south on Cheney-Plaza Road; in 4.5 miles you'll arrive at the refuge entrance.

Turnbull National Wildlife Refuge: 509-235-4723;
www.fws.gov/refuge/Turnbull

5. Wheat Country

Interspersed throughout northeastern Washington's channeled scabland is a remarkable legacy of farming, particularly wheat farming. This history goes back to the original settlers, who first recognized the region's promise. The eastern plains only became profitable farmland in the 1930s, when gigantic dams began to appear on great rivers like the Columbia. Irrigation effectively brought life to the land, and agriculture continues to be a strong presence in the region today.

Compelling stories are to be found along lonely dirt roads, and this is certainly the case in northeastern Washington. There's no telling how many dirt roads we have traveled over the years, but seldom are we disappointed by either the journey or the destination. Down almost every gravel road in this part of Washington you'll discover proof of someone's farming dream, the shell of an old schoolhouse, or an abandoned truck once shiny and new. They all have a story to tell, and there is perhaps no more enjoyable task in photography than to record our human past.

Washington Tourism Alliance:
www.experiencewa.com

6. Lake Roosevelt National Recreation Area

Before the arrival of immigrant settlers to this part of Washington, the Columbia River, from its mouth on the Pacific Ocean to its Canadian tributaries, served as a primary source of survival for Native people. Dams changed the course of life along the river. Today, dams like the Grand Coulee supply much-needed electrical power to Washington's interior and coastal regions as well as metropolitan centers like Seattle and Tacoma. They are also essen-

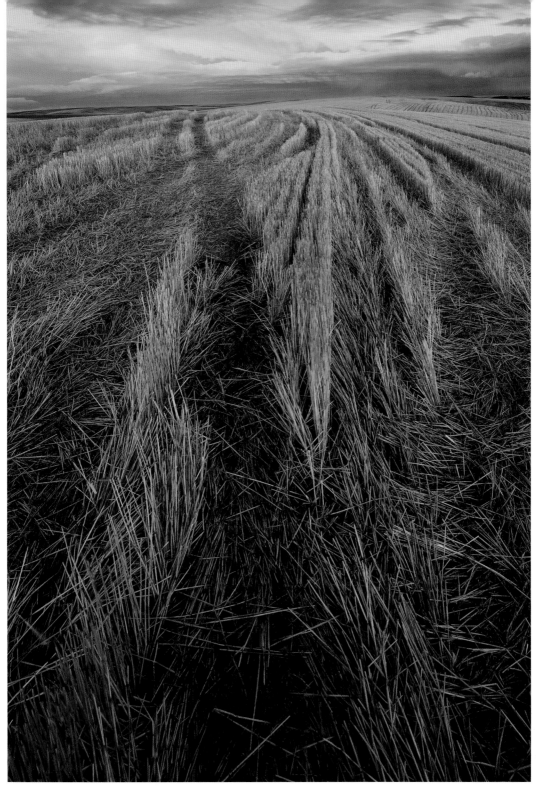

A low-angle view of Wheat Country adds visual interest.

Look for natural curves to enhance composition.

tial to irrigation and farming throughout the eastern half of the state.

The completion of Grand Coulee Dam backed up water almost to the Canadian border, creating Lake Roosevelt National Recreation Area. The extensive area is a favorite for boaters, campers, and fishermen. For photographers, it abounds with natural scenes, and the massive concrete structure of the Grand Coulee is a tribute to human ingenuity.

Lake Roosevelt National Recreation Area: (509) 754-7800; www.nps.gov/laro/index.htm

7. Dry Falls, Sun Lakes State Park

During the long life of Glacial Lake Missoula, intermittent floods raged through natural drainage areas and basins throughout eastern Washington. One drainage included a circular series of basalt cliffs where one of the largest waterfalls ever to exist appeared each time the floods raced across the rugged landscape. Today, what remains of the falls, cliffs, and ex-

cavated basin below comprises Dry Falls, part of Sun Lakes State Park. Facing the Dry Falls precipice, it is easy to conceive of the days when the floodwaters washed over it, and to imagine the thundering roar as over 500 cubic miles of water descended, excavating over time the huge basin below.

For the photographer, the options are somewhat limited, as the best vantage point for Dry Falls is the park overview. Nonetheless, the area is both fascinating and picturesque. We find late afternoon, before the sun sinks low enough to spread dark shadows across the impounded water, best for photography. Sunrise also works, but will take at least two stops of graduated neutral-density or advanced HDR.

Washington State Parks: 888-226-7688; www.parks.wa.gov/298/Sun-Lakes-Dry-Falls

8. Crystal Falls

Crystal Falls is accessible from WA 20, about 14 miles east of Colville.

As a nature photographer, you can't help being drawn to waterfalls: they rank as one of nature's most soothing sites. Crystal Falls is a good location to put your skills to work.

Before you get started, consider how you want the final image to look. Do you want the waterfall to appear light and airy? If so, a slow shutter speed, perhaps a 15th of a second, is best. Or do you want it to look more realistic? In that case, "freeze" the falling water with a shutter speed of 250th of a second or more. For a nice compromise, select a shutter speed somewhere in between. We very often bracket waterfalls in full stops to create the exact image we want. One of the biggest problems with waterfalls is clipping highlight areas, especially if we have let the water flow past the lens with a slow shutter speed. After each shot, we consult the camera's histogram to make sure the right side of the graph shows no clipping. This is one instance where shooting on the dark side can result in a great image.

Colville National Forest: 509-684-7000; www.fs.fed.us/r6/colville

9. Banks Lake

As floodwater from Glacial Lake Missoula scoured the upper Columbia Plateau, it exposed huge banks of basalt left by ancient lava flows. These appear today as prominent cliffs

Before sunset, dark shadows can be used to advantage.

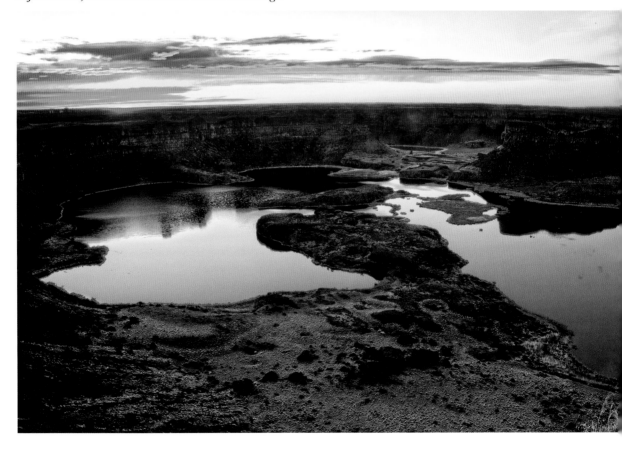

looming hundreds of feet above the surrounding landscape. The cliffs east of Banks Lake are a prime example, well weathered and covered with colorful lichen eating away as the primordial rock cycle inches onward. Eventually, the cliffs will crumble. Meanwhile, they stand prominently against the open sky and make for wonderful landscape pictures. We like to work here in midspring, when the dogwood bushes around the base of the cliffs are in bloom.

The cliffs on both sides of the lake form a great horizon at sunset. If you arrive on an evening with clouds above the lake, prepare for a truly wonderful display. Several stops of neutral density will be needed to balance the scene.

Washington State Parks: 888-226-7688
www.recreation.gov/recAreaDetails.do?
contractCode=NRSO&recAreaId=1206

10. Steamboat Rock State Park

Perched northwest of Banks Lake is the historic and picturesque Steamboat Rock. This massive chunk of basalt served as a landmark for early travelers to the Columbia River Basin. Some experts believe the use of the rock as a landmark goes back to the earliest hunter-gatherers who entered the area over 10,000 years ago.

Today, a beautiful state park and abundant campground occupies ground below Steamboat Rock. There are a number of trails begin-

Huge basalt cliffs define the sheer ruggedness of the northeastern landscape.

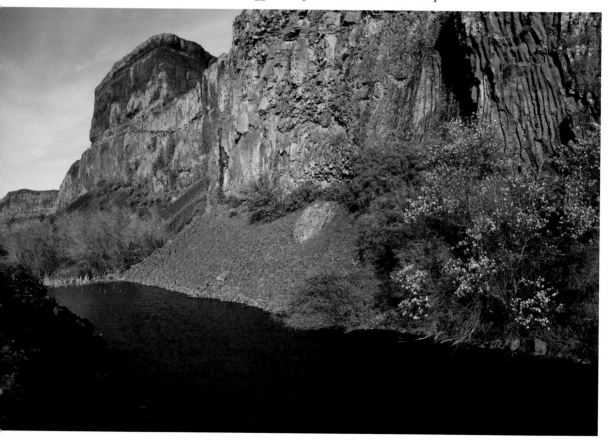

ning west of the road above the campground. The trails wind toward the base of Steamboat Rock. We like to hike this area in late May, when bright yellow arrowleaf balsamroot blanket the sun-parched ground and provide a great foreground for the rugged cliffs beyond. One caution here: beware of rattlesnakes.

Washington State Parks: 888-226-7688

11. Sherman Pass

Reaching an elevation of 5,587 feet, and flanked by Copper Butte to the north and Snow Peak to the south, the Sherman Pass highway threads through the Okanogan National Forest and parts of the Kettle River mountain range.

The pass is part of WA 20, and in summer the striking forested region offers a host of photographic opportunities. Perhaps our favorite time here, though, is winter. Covered with deep snow, the tree-lined valleys and gullies surrounding the pass are truly impressive. Winter enhances the area's remote and wild appearance, and the drive is replete with landscapes, from open farmland to deep forests. This part of the state is cold in winter and receives heavy snowfall, so come prepared, and heed travel advisories.

Washington State Department of Transportation: www.wsdot.gov

West of Sherman Pass

12. Mountain Loop Highway

A hidden photographic treasure, Mountain Loop Highway WA 530 in Snohomish County is anchored on the west by the town of Arlington and on the east by Darrington. The highway snakes through dense forests edged by wilderness. The secluded drive features the western exposure of 10,541-foot Glacier Peak and Glacier Peak Wilderness as well as paralleling the remote Boulder River Wilderness

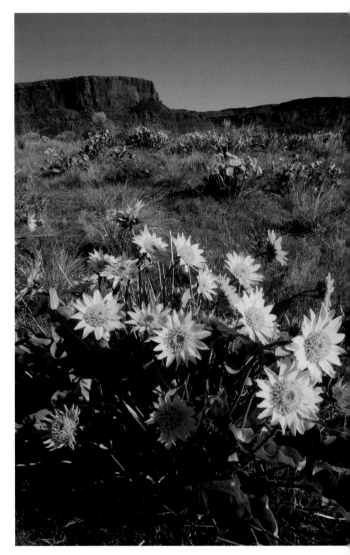

Early spring is a prime time for wildflowers on the northeastern plains.

Area. From the highway, a labyrinth of trails are available. The highway also serves as the gateway to little-known Camano Island via WA 532, a bird-photographer's paradise. Glacier Peak is an active volcano and ranks as one of Washington's iconic sites.

Snohomish County Tourism Bureau: 425-348-5802; www.snohomish.org

On overcast days, consider including only a narrow band of sky, with plenty of interesting foreground.

South of Sherman Pass

13. Methow Valley

When you enter the Methow Valley on WA 20 just west of Loup Loup Ski Bowl, you'll immediately see what attracts area photographers to this region. To the northwest, North Cascades National Park dominates the horizon; to the southwest, the Cascade Range rises; and directly ahead, one of Washington's most prominent and popular valleys spreads out before you.

In winter, the area is a cross-country skier's mecca, complete with plenty of fresh snow and a laid-back attitude well appreciated by visiting photographers. The best time for us in the Methow Valley is indeed winter, when the rugged region is rendered white in seasonal spender.

Practically everywhere you look, a vivid picture tempts the creative muse. Bisected by the Chewuch River, the valley is a prime spot for scenic images. Its high mountains, snow-covered forests, and surrounding highlands provide ample background for great landscape and midrange pictures alike. The mountain towns of Twist and Winthrop add further interest. If you plan a photographic visit in winter, bring plenty of warm gear and take along your cross-country skies or snowshoes to venture offroad.

Methow Visitor Center: 509-996-4000

14. Sun Mountain Lodge

Situated on a prominent hill overlooking the Methow Valley to the east and the Mazama Valley to the northwest, Sun Mountain Lodge is a wonderful place to work on panoramic landscapes during any season. Winter, however, is our favorite time here. At the lodge's high elevation, most mornings awake to heavy frost. Bushes and trees are communally coated with frost and will keep you busy throughout the morning while the sun brightens the mountains in the background. Bright morning light very often follows a subzero night, something to keep in mind on Sun Mountain. Watch for prominent shadows on crisp snow to use as interesting foregrounds.

If you want to photograph on the property and are not a guest at the lodge, it is a good idea to check with the front desk before you begin. In our experience they are very welcoming of nature photographers.

Sun Mountain Lodge: 509-996-4705; www.sunmountainlodge.com

15. Mazama Valley

Mazama Valley serves as the eastern gateway to the North Cascades Highway and National Park, but certainly offers its own palette of year-round beauty. Again, winter is our favorite time here, with spring a close second.

Like the Methow Valley, the Mazama Valley draws cross-country skiers from throughout

In winter, isolate smaller scenes that tell their own story.

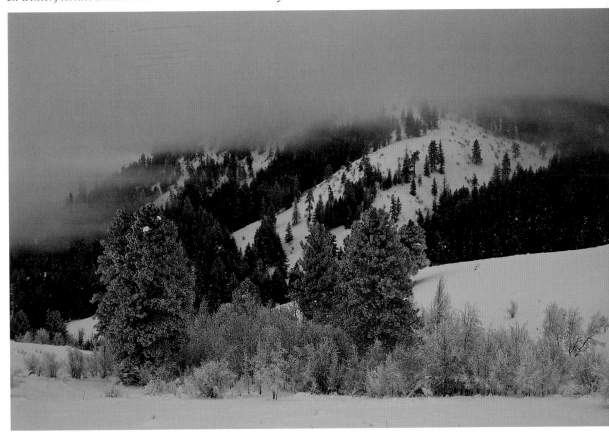

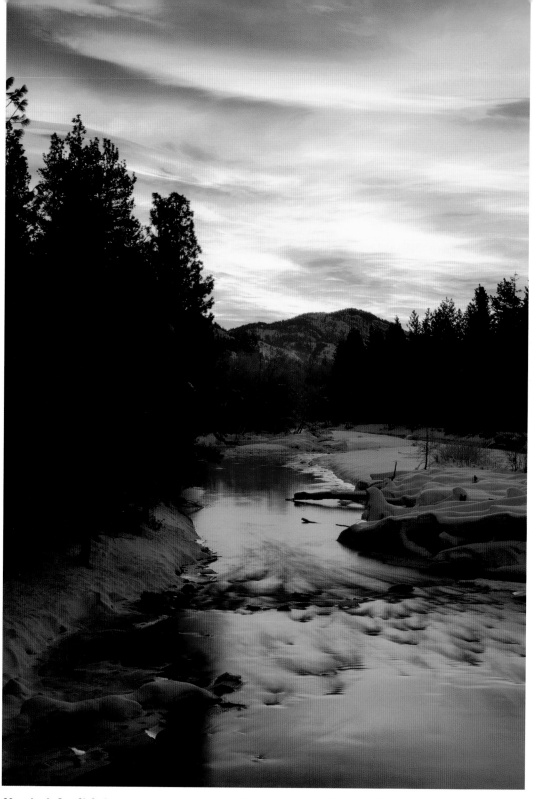

Morning's first light is warm and high-contrast. Three-stop neutral density filtration balances the scene.

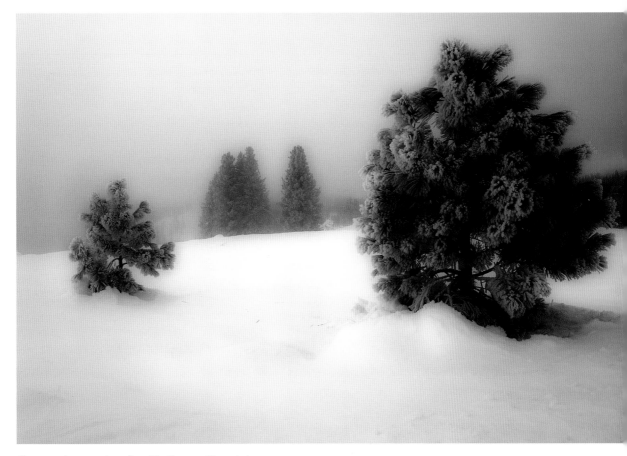

Compose in monotone for effective smaller winter scenes.

the Northwest, making winter accommodations and photographic access no problem. Surprisingly, there are plenty of bright, sunny winter days in this part of Washington, despite the cold climate. We find a midwinter visit here usually results in impressive winter scenes, including panoramic landscapes with the North Cascade mountains on the western horizon.

There is no dispute about it in our photographic family: midwinter is an early-morning and late-afternoon gig. Winter light in morning is nothing short of fantastic, and adds climatic contrast to a variety of frigid scenes. We tend to get up early and photograph late into the day in the Mazama Valley. Midday, when light on snow gets far too intense, we generally strap on the skies and join other enthusiasts.

U.S. Ranger Station, Leavenworth, WA: 509-548-6977

16. Okanogan National Forest, Gateway to North Cascades National Park

The terrain around North Cascades National Park makes up some of America's wildest and most beautiful mountain scenery, with 94 percent of it federally designated as the Stephen Mather Wilderness. The area includes an abundance of jagged peaks, cascading waterfalls, crystalline streams, sheer-walled cliffs, and snowfields. The North Cascades Highway,

WA 20, effectively parallels the boundary of North Cascades National Park for a considerable distance after traveling through the Mazama Valley and topping out at Washington Pass. The highway continues westward, finally summiting 4,855-foot Rainy Pass, where it crosses the Pacific Crest Trail. Along its course through the Okanogan National Forest, the highway, which opened in 1972, passes a host of great photographic sites prominently marked along the way and including:

Silver Star Mountain
Early Winters Spires
Blue Lake
Rainy Lake
Cutthroat Pass

Time spent on the North Cascades Highway will certainly reap photographic rewards, markedly in early spring following its opening in May, or in autumn, when highland color reaches its peak—mid-October. If you plan an outing in this area, give yourself plenty of time, get a topographic map of the North Cascades from which to plan short day hikes, and by all means, take advantage of roadside vantage points.

Okanogan-Wenatchee National Forest: 509-996-4003

Winthrop Chamber of Commerce: 888-463-8469; www.winthropwashington.com

17. Lake Chelan and Stehekin

Camp Chelan was established at the head of Lake Chelan, to service miners and loggers in the short boom years of the 1880s. The camp saw a few good years while logging and mining prospered, but eventually began a steady decline. Fortunately, the designation of North Cascades National Park in 1972 revived it. The area is now devoted heavily to tourism inspired by its natural beauty and the outstanding recreational opportunities provided by the huge lake and bordering wilderness.

Lake Clelan is 51 miles long, 5 miles wide, and reaches a depth of 1,486 feet, which makes it the third-deepest in the United States after Crater Lake and Lake Tahoe. Set close to the mountains including Pyramid Peak, the lake offers good sunrise and sunset shots.

One of its foremost attractions is the remote town of Stehekin, located at the far end of the lake. Stehekin is accessible almost exclusively by boat, including a commercial passenger ferry *(Lady of the Lake)* departing Chelan. The small town serves as an entry point to both North Cascades National Park and Lake Chelan National Recreation Area, and abounds with photographic possibilities.

If you are planning a backcountry outing in the area, you can camp, on a first come, first served basis, at one of the 200 walk-in or boat-in campsites. You can also camp at least 1 mile from other campsites or .05 miles from trails. Lugging photographic equipment along with backcountry camp gear for any distance isn't easy, we know, but a campsite makes a great home base for photographing here, and if you're up to it, the rewards far outweigh the hassle.

Lake Chelan Chamber of Commerce & Visitor Information Center: 800-4-CHELAN; www.lakechelan.com

18. Cascade Pass Trail

Another option for accessing North Cascades National Park is the 11.7-mile Cascade Pass Trail leading from Cascade River Road (off WA 20 at Marblemount) to Stehekin and the park. This option is not for the weak at heart, however, particularly if you're carrying both camera equipment and backcountry gear. In its first 3.7 miles, the trail gains 1,800 feet of elevation before it summits the pass at 5,400 feet. The reward, of course, is the outstanding wilderness view stretching in all directions

from the summit, as well as the 8-mile downhill trek to Stehekin.

If backcountry photography is your goal, the Cascade Pass trail is a definite consideration. You can also hike to the pass and make a day trip of it. There are several dozen longer hikes inside North Cascades National Park that can be reduced to day hikes if divided into sections. Of special consideration are trail sections that summit passes, weave through mountain valleys, or border alpine lakes. In planning any backcountry journey, invest in a good topographic map of the area. They are usually available at national park visitor centers or Forest Service headquarters.

Lake Chelan Chamber of Commerce
& Visitor Information Center:
800-4-CHELAN; www.lakechelan.com

19. Pacific Crest Trail

North Cascades National Park is a hiker's paradise, whether you take to the trail in the park itself or in surrounding wilderness, recreation areas, or national forest. Access to great mountain photography is afforded by all. The Pacific Crest Trail bisects the park effectively from

For foliage in autumn fog, use a slightly warmer white-balance adjustment.

Rainy Pass in the east to High Bridge campground in the west.

Consider hiking parts of the trail for outstanding backcountry photography; consult either a topographic map or the North Cascades National Park Map for reference. For day trips, plan an early-morning departure so you can reach a good vantage point in midmorning

Predawn street scenes require long exposures and slow shutter speeds. Use low ISO to avoid noise.

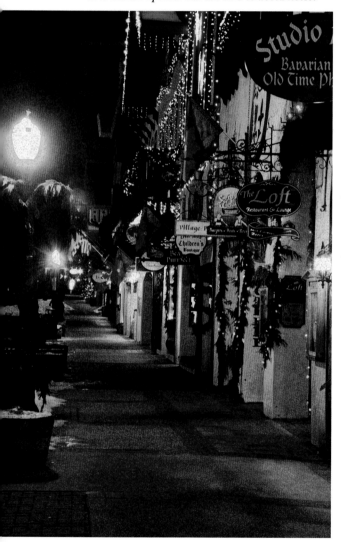

light. Remember to lug along a polarizing filter to reduce distracting haze over the mountains and brighten ambient colors and sky.

Pacific Coast Trail Association:
916-349-2109; www.pcta.org

20. Leavenworth

Washington is renowned for quaint towns like Leavenworth, located on the eastern flank of Stevens Pass along WA 2. In summer, Leavenworth is a bustling tourist town with streets lined with small shops and great eateries. Surrounded by rugged mountains and the constant babble of Icicle Creek, the area is host to summer travelers, who arrive in flocks. In winter, however, the story changes as Leavenworth decorates its streets for the holiday season. This is our favorite time to visit.

The prime time to photograph the festive lights in Leavenworth is very early in the morning, before traffic begins. A sturdy tripod and long time exposures are necessary. Take your initial exposure reading from the scene you are about to photograph and bracket at least two to three full f-stops to either side. You might find darker images a bit more pleasing on the monitor, but lighter ones are easier to process into usable files. Full f-stop brackets are enough, but make sure you get plenty of exposures to select from. Keep in mind a digital law: contrast is easy to increase during processing but very hard to diminish. So, slightly lighter images of the Leavenworth lights might be what you're after.

Leavenworth Chamber of Commerce:
509-548-5807; www.leavenworth.org

21. Icicle Creek

As it ascends the summit of Stevens Pass from Leavenworth, WA 2 parallels Icicle Creek, which gushes from the surrounding high country. Few waterways rage wilder, especially during spring runoff, making it truly a mar-

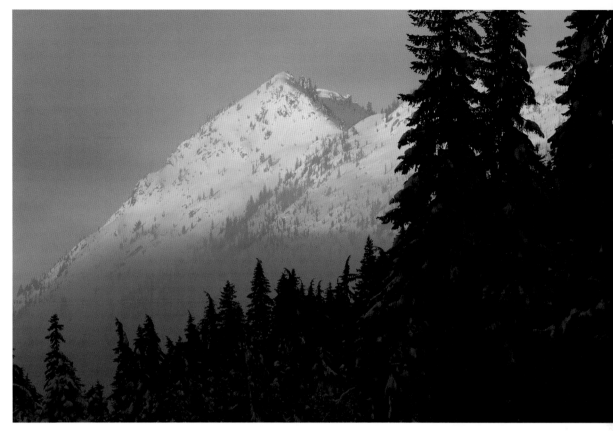

Stevens Pass is a prime location for majestic mountain shots. Take care in winter not to clip snow scenes.

vel to photograph. Several pull-offs along the route give good access to photographers, and impressive images are possible.

We like to use longer lenses, 80 to 200 zoom, for example, to isolate close-up sections and midrange scenes. Winter is special on Icicle Creek, particularly for closer-in scenes. The water flows very fast, so be careful not to clip highlights, especially in winter. Clipping highlights can be a real problem if a slow shutter speed is used. Take special care to consult the histogram after every shot to be certain there is enough detail throughout the scene. Don't trust the monitor on this occasion.

Leavenworth Chamber of Commerce: 509-548-5807; www.leavenworth.org

22. Stevens Pass

Icicle Creek is just one of the photo-worthy subjects encountered as you climb to the 4,061-foot summit of Stevens Pass. In summer, the route is impressive, with ample small streams and nice waterfalls, but in winter, when the mountains skirting the pass are piled with snow and early-morning fog lifts from valley floors, is when we most like to photograph here.

On the summit, Stevens Pass Ski Area and the ridges above glisten in morning light. Descending the west flank of the pass, WA 20 bisects Alpine Lakes Wilderness to the south and the Henry M. Jackson Wilderness to the north. We find the west side more interesting. For vivid winter-landscape pictures, consider a

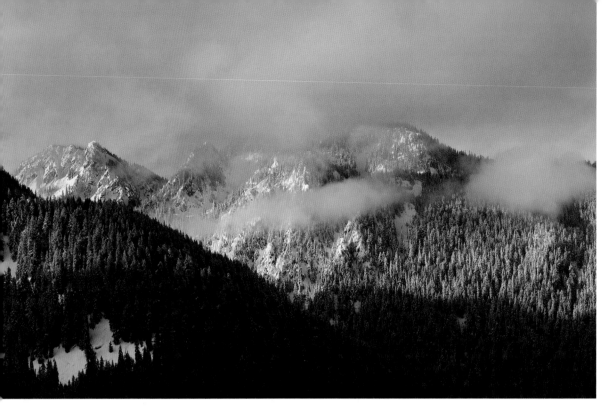

Rugged wilderness mountains are found on both sides of Stevens Pass. Use a polarizing filter on clear days to darken the sky.

polarizing filter; for sharp distant images, use a tripod.

Leavenworth Chamber of Commerce: 509-548-5807; www.leavenworth.org

23. Alpine Lakes Wilderness Area

During any season, settings like Alpine Lakes Wilderness Area define wilderness and its valued place in our busy world. In winter, the wilderness takes on a special character, and you don't have to venture far off the road, via skis or snowshoes, to photograph it in all its pristine glory. Summer in the Alpine Lake Wilderness is also fantastic.

The 394,000-acre area includes rugged mountains, emerald lakes, and ponds. A labyrinth of streams and open meadows are backstaged by craggy peaks.

Alpine Lakes lies between Snoqualmie Pass on I-90 to the south and WA 20 and Stevens Pass to the north. Wilderness access from either pass is clearly marked. We generally take day hikes in this area, and usually lug along enough gear to take advantage of a wide variety of scenes, and even a midrange telephoto (300) in the event of wildlife. A usual day pack for us weighs a little over 35 pounds.

U.S. Forest Ranger Station, Leavenworth: 509-548-6977

Washington Tourism Alliance: www.experiencewa.com

24. Henry M. Jackson Wilderness Area

The Henry M. Jackson Wilderness contains some very rugged country, but taking on the terrain is well worth the effort. We do short day

hikes here, hefting the same pack we use for Alpine Lakes (site 23). Both areas are crossed by the Pacific Crest Trail, which also provides great access. As you hike these backcountry sites, it's interesting to recall the region's origins, how the Cascade Range joined the Old West Coast, eventually forming the area we experience today.

U.S. Forest Ranger Station, Leavenworth: 509-548-6977

Washington Tourism Alliance: www.experiencewa.com

25. Omak Stampede

Rodeos like the Omak Stampede are exciting events to photograph and add a wonderful human dimension to any creative portfolio.

Living in rodeo country, we have learned a few tricks worth passing along. First, this sub-ject requires you to stop fast action, so select a sufficient shutter speed, 1/500th to 1/800th of a second. In some cases, we use the shutter-preferred feature on our cameras. Before the rodeo begins, we scope out the scene, selecting a number of shooting locations. These locations provide a suitable background for the action, usually incorporate direct light, and give us the proper angle from which to record the action.

Aside from these considerations, we feel the single most important element in rodeo photography is capturing "peak of action," that split second when everything comes together. It takes a little practice, but in time you'll be able to sense in advance when the peak moment is approaching: that's the time to trip the shutter. Billowing dust, dirt flying, fringe in motion on a contestant's shirt or chaps, an es-

Panning with the subject helps freeze rodeo action. Let the autofocus do its job for best results.

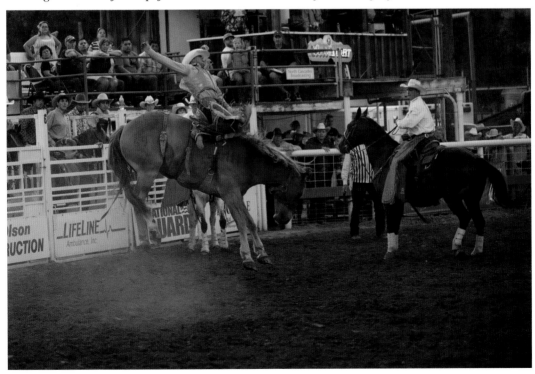

pecially intense facial expression, these all add to peak of action.

Another tip on rodeo day: look for sideline scenes, contestants chatting or resting, small kids playing. Rodeo is not only about the animals and their riders, it's about a way of life.

Omak Stampede: 509-826-1002; www.omakstampede.org

Facial expression conveys emotion, adding to the effect of this image. A short telephoto lens with higher ISO is helpful here.

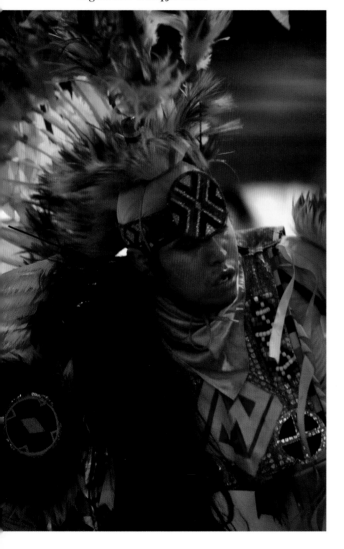

26. Omak Indian Encampment and Powwow

Inspired by the state's colorful Native American history, each year Washington plays host to several powwows, or cultural gatherings with traditional dance and song. They are a pleasure to watch and photograph.

First, before you shoot, find out from event officials if any rules or special considerations with respect to photography apply. Remember, these are very personal events and important to the cultural heritage of Native Americans. Gatherings like the one held at the Omak Stampede Grounds each August offer a mixture of fast action (dancing) and rich human story. For the fast action, be mindful of capturing "peak of action," that single moment when it all comes together: a perfect facial expression, a special movement, a remarkable blending of colors, for example. Setting the camera on continuous shooting mode can be of help here. Otherwise, after determining exposure settings and making sure of sufficient shutter speed, follow your subject through the viewfinder and wait patiently for the prime shot. Depress the shutter very slowly so as not to jerk the camera.

Omak Stampede: 509-826-1002; www.omakstampede.org

27. Ginkgo Petrified Forest State Park

Located just outside Vantage, overlooking the Columbia River, Ginkgo Petrified Forest State Park holds out a special photographic opportunity. Eons ago, before the Columbia Plateau was formed, forests covered the area. Much of the forest was consumed by molten lava; some trees, however, found their way into muddy swamps and were preserved. Submerged in mud, minerals took the place of soft tissue in the trees, petrifying them. Samples are on display at the state park.

We like close-up images of petrified wood,

Framing the image leads the viewer's eye to the primary subject.

and very often select early-morning low-angle light to emphasize the beautiful patterns. A tripod and electronic or cable shutter release is a must to eliminate camera vibration.

> Ginkgo Petrified Forest State Park: 509-856-2700; www.parks.wa.gov

28. Fort Spokane

With the arrival of settlers in northeastern Washington in the late 1800s, tension mounted between newcomers and Native people. Fort Spokane was constructed at the confluence of the Spokane and Columbia Rivers to bolster the presence of the U.S. military during the final stage of white settlement in the area. Two decades later, after settlement on the frontier closed, the fort became an Indian boarding school and tuberculosis sanatorium.

Serving as a constant reminder of the era of conflict following western settlement, the fort now rests within the borders of Lake Roosevelt National Recreation Area and features several well-maintained buildings, including a stately quartermaster's barn.

> Fort Spokane Visitor Center: 509-725-7800; www.nps.gov/laro/historyculture /fort-spokane.htm

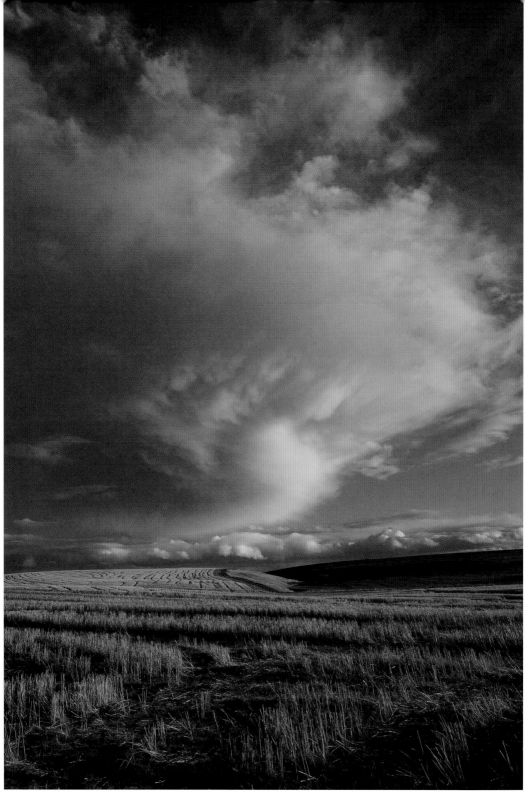

Passing storms add drama to farm scenes, particularly just before sunset.

II. The Southeast Columbia Plateau

Following the release of lava, which in some places covered the Colorado Plateau thousands of feet deep, glacial floods began the work of sculpting the landscape into what we see today. Both molten lava and floodwater naturally followed the physical contours of the land and eventually found their way to the Columbia River basin by way of hundreds of natural tributaries. Glacial water raged through southeastern Washington, deepening existing coulees and canyons along the way until finally reaching the beautiful Columbia River Gorge, where the work continued.

Excavated by floods, large punchbowls like those below Palouse Falls and Dry Falls serve as a reminder of the power of flowing water across a landscape. The southeastern section of Washington is a wonderful place to observe and photograph the geography resulting from these catastrophic events. Throughout the region, it is not uncommon to see the large remnants of these events in the form of deep basalt-lined canyons, picturesque buttes, and prominent cliffs. The eastern half of the Columbia River Gorge is an outstanding example, especially areas like Horsethief Butte and Columbia Hills State Parks.

29. Palouse Scenic Byway

Some of the most fertile farmland in the Pacific Northwest rests in Palouse Country, where rolling hills stretch from horizon to horizon. The farmland changes dramatically as seasons come and go. In spring, a vibrant green palette dominates the scene; yellow comes in summer; and a golden hue arrives in autumn.

Known for both wheat and hay, the farmland around the Palouse River offers extraordinary pastoral scenes perfect for photography.

Low-angle light and strong foregrounds add interest and intrigue to Farm Country scenes.

The Palouse Scenic Byway is a must on your photographic excursions, so make sure to give yourself enough time to cover the 208-mile paved loop.

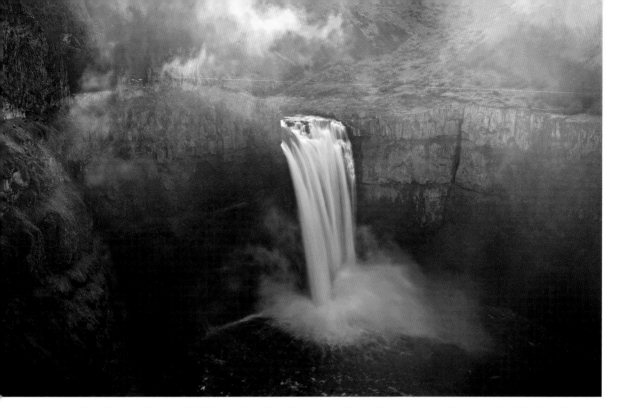

First light at Palouse Falls is special. Slow shutter speeds and long lenses isolate just the right detail.

The byway begins in Pullman and includes a series of spurs that radiate out from the main route. Washington 27 from Pullman travels north through Palouse to the small town of Oakesdale, while WA 271 continues north to Rosalia, and finally U.S. 195 heads south to Colfax and eventually loops back to Pullman. Also along the route are several side roads taking off in different directions, mostly through surrounding farm country.

Late spring, when everything is fresh and summer traffic has not yet arrived, is our favorite time to photograph the Palouse Scenic Byway.

Most images on the byway will stop you in your tracks; a map is really not necessary. Pull-offs and gravel roads are common. A special experience for us is to find a secluded back road and just go exploring.

Washington Tourism Alliance:
www.experiencewa.com

30. Palouse Falls State Park

The physical geography around Palouse Falls consists of steep, dark basalt walls surrounding the falls and the canyon below. They were chiseled out first by floods and finally by the relentless flow of the Palouse River through the hardened landscape. Experts tell us the original site of Palouse Falls existed where the river dumped into the Columbia River. Floods and natural erosion brought the falls to its present location.

Late morning or early afternoon, when the sun is high enough to light both sides of the deep canyon while still providing texture to the surrounding landscape, is the best time to photograph here. Two prime locations are pro-

vided: one directly overlooking the falls and another a little farther south, which allows for a broader view of the falls and the punchbowl below. The second overlook is also a select spot to photograph the dark canyon country south of the falls.

To capture both the falls and the sky above try either a graduated neutral-density filter or a number of images blended as HDR.

Washington State Parks and Recreation Commission: 360-902-8844; www.parks.wa.gov

31. Steptoe Butte State Park
From the summit of Steptoe Butte you can photograph surrounding farmland virtually from horizon to horizon. The rolling topography of Palouse Country adds considerable intrigue to these shots. The butte is also a popular launching site for hang gliders, which will spice up your landscape images with a little color and action.

When photographing across distant scenes like farmland, use a polarizing filter to heighten color and reduce haze. Early morning under low-angle light is best here, particularly if light enters the shot from the side and rakes across the hilly landscape. Sidelight lengthens shadows, which gives the rolling farmland interest and character while increasing depth.

Steptoe Butte State Park: 360-902-8844; www.parks.wa.gov

32. Wheat Country, Southeastern Farmland
If given the opportunity, I believe Cathie and I would spend decades chasing clouds and beautiful light across Washington's eastern plains. The drama of colorful skies over farmland contributes greatly to the beauty of southeastern Washington.

Strong sidelight adds dimension to surrounding farmland. A polarizing filter will saturate color.

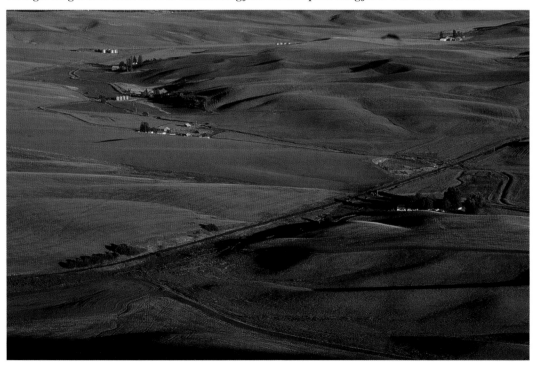

Here, rolling hills stretch from horizon to horizon as far as the eye can see. A hundred miles to the west, enormous Pacific storm clouds gather over the mountains and are finally ferried eastward. Standing in front of your tripod-mounted camera, you can see the massive clouds coming, like crashing waves relentlessly reaching out for land.

In midafternoon we like to watch the clouds drift aimlessly across the sky, at times gathering mass, at other times splitting apart. Picking a good spot with well-defined geography, we sometimes wait half a day for the right light and right contrast to photograph encroaching clouds, and we are seldom disappointed. Intense sidelight works best for this type of landscape work.

We like to select a vantage point where strong rim light accentuates hilltops, and lengthening shadows add definition and contrast. This is a good time to bracket a few stops on the dark side. One f-stop might make all the difference in the world.

We can't say enough about the colorful cloud formations that roof southeastern Washington. Early spring is good, but midsummer, July, perhaps, when thunderstorms pass overhead, is our favorite time to photograph Wheat Country.

Washington Tourism Alliance:
www.experiencewa.com

33. Saddle Mountain National Wildlife Refuge, Columbia River

In the 1940s, Hanford Nuclear Research Reservation was created to perfect the production of nuclear fuel for weapons. Research finally led to the atomic bomb. Water was criti-

Vast open landscapes have photographic appeal when conditions are right. Emphasize strong foregrounds.

cal to the process, hence the closeness of the site to the Columbia River.

As a result of the supersecret work conducted at Hanford, a large section of the Columbia River became inaccessible to the public and now represents the largest undeveloped section of the Columbia River. Today, the area is home to the Saddle Mountain National Wildlife Refuge.

Walking the desert-like terrain surrounding the refuge inspires the imagination; the landscape here is distinctive. Saddle Mountain is a wonderful place to capture arid desert scenes and huge sky. You might want to guard against dust as you hike available trails, and be sure to keep an eye out for birds that inhabit the desert.

Saddle Mountain National Wildlife Refuge: www.fws.gov

Hanford Department of Energy: 509-372-1145; www.hanford.gov

34. McNary National Wildlife Refuge

WA 14 bisects McNary National Wildlife Refuge, located just east of Pasco. Access to the refuge is provided via secondary roads on either side of the highway.

The refuge is a good place to photograph a number of bird species, both migratory and resident. American white pelicans are a common sight here, as are blue herons along the shore. We've also encountered small migratory species and an array of insects, including colorful dragonflies.

Wildlife refuges are managed as wild environments; familiarize yourself with the guidelines in order to take full advantage of this site as a photographer. Late evening is best for us at McNary because the western light seems to rake across the refuge, adding contrast. McNary is also a wonderful place for landscape photography. Sunset here can be outstanding, and offers a glorious end to a successful day

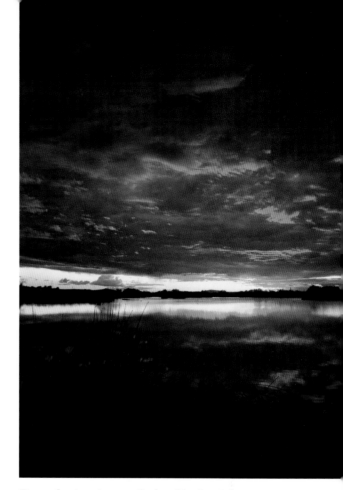

Remember to expose vertical and horizontal images. Compose differently for both.

photographing birds and insects. A longer lens with tripod makes things easier but is not an absolute necessity; 300mm will work.

U.S. Fish and Wildlife Service: 800-344-WILD; www.usfws.gov

35. Columbia River Gorge Scenic Byway, East

The Columbia River Gorge Scenic Byway, WA 14, begins near the small town of Plymouth and continues to Camas. One of the first sites you'll come to along the route is McNary National Wildlife Refuge (site 34), a treasure

The gorge seems to create its own weather. Patience pays off. Here, dramatic clouds dominate the scene.

in itself. Traveling westward, a number of other good photographic sites appear.

The Columbia River Gorge is well worth a slow drive, especially in early morning when eastern light beams down parts of the gorge. Keep an eye open for sites like Dog Creek, where each spring, a wonderful waterfall cascades over a sheer basalt wall. More prominent sites are Horsethief Butte and Columbia Hills.

For landscape photographers, there is always the temptation to rush from one iconic site to another, bypassing less well-known subjects in between. Try to slow down and, as you travel along the gorge, be mindful of where the light is coming from and when it will be illuminating sites along the way.

Columbia Gorge Interpretive Center: 800-991-2338; www.columbiagorge.org

36. Horsethief Lake State Park

You can stand at Horsethief Lake State Park and photograph beautiful landscapes in all cardinal directions. Colorful cliffs rise from the floor of the Columbia Plateau to catch warm morning sun. Just beyond Horsethief Butte, to the south, lies the mighty Columbia River and Horsethief Lake.

Low evening light works best here as it rakes across the rugged terrain in front of the cliffs. Morning light is also prime. This area is a fine example of the deep volcanic cover that eons ago capped the Columbia Plateau. We like to use a polarizing filter to add drama and separation between the rugged basalt stone and the open sky. If clouds are present, the effect is enhanced. The filter also adds color contrast to layers of lichen on the cliffs.

Horsethief Lake State Park: 509-767-1159; www.parks.wa.gov

37. Columbia Hills State Park

A short drive west from Horsethief Lake State Park is another great cliff area, Columbia Hills. Here trails lead to the very base of outcrops hundreds of feet above the plateau. In spring, the terrain lying at the base of the cliffs is covered with wildflowers, adding a delicate contrast to the rugged stone above.

A wide-angle lens is effective for this type of work. The trick is to get as low and close to the flowers as possible so they have nice definition. Make sure the cliffs in the background are also in sharp focus. F-22 is our normal f-stop for this type work, and we always use a low-level tripod about 24 inches from the ground. Remember, the smaller the f-stop the greater the depth of field. If the flowers are moving even slightly, increase the ISO to quicken shutter speed.

Columbia Hills State Park: 509-767-1159; www.parks.wa.gov

38. "She Who Watches" National Historic Site

It remains a mystery what message Native Americans intended hundreds of years ago when they created rock art like that etched on dark basalt stone at what is today Columbia Hills. One story, however, has to do with a woman, Tsagaglalal ("she who watches"), who was a chief until the trickster Coyote came along and declared that a woman could no longer hold that exalted position. An altercation ensued, and Tsagaglalal was slammed against a rock wall, where her visage remains today as one of the most recognizable petroglyphs in the area.

Rock art on display at the site originally came from a canyon flooded by the 1957 completion of the Dalles Dam, miles away. There are a number of interesting rock art pieces open to viewing by the general public at the entrance; for a more complete display, guided tours on Native land are provided. We always recommend tours, especially if conducted by area Natives. Oftentimes the stories behind the art are as valuable as the antiquities themselves. Bring a long lens and make sure to darken your

Move in closely to capture the detail of the etched stone.

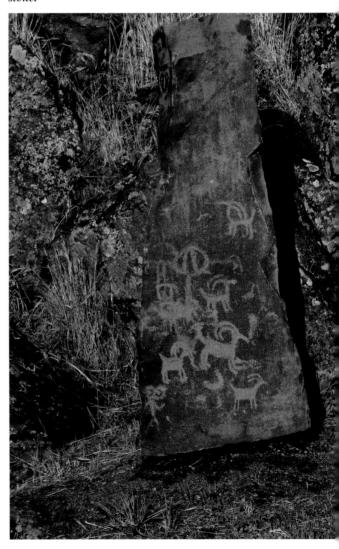

images a stop or more to add contrast. Don't let your meter get fooled by the dark stone.

State Parks, Dallesport, WA: 509-767-1159

39. Maryhill Museum of Art

The 5,000-acre estate at Maryhill was built in 1914 as the home of entrepreneur Sam Hill, son of railroad tycoon James Hill. Hill envisioned the vast property overlooking the Columbia River, named after his daughter, as an agricultural community. When his plans for an agrarian community failed to materialize, he turned the estate into a wonderful art museum.

Joining an unusual collection of art and old photographs are some ornate collectibles once the property of Queen Marie of Romania, who for a time owned Maryhill. The site offers an intriguing slice of Washington history and is interesting to photograph.

There is a restriction on use of tripods and monopods. For commercial or press-use photography, request a permit at the registration desk.

Maryhill Museum of Art: 509-773-3733; www.maryhillmuseum.org

40. Walla Walla

A historic town with plenty of photographic interest, Walla Walla is located on U.S. 12.

Cathie and I always return to a couple of well-manicured gardens situated in town. Xeriscape Park offers a peaceful setting for flower photography. Pioneer Park is larger, just off Alder Street. The park grounds are very photogenic, particularly under early-morning light. There is an outstanding rose garden maintained by local garden club members that can't fail to spark your creativity. This is

Frame large-structure shots for emphasis.

a wonderful place to capture any number of different rose species in a remarkable natural setting. The waterfowl aviary adjacent to the rose display is also a nice subject. Bring along a misting bottle to added additional interest to flower images. Early morning or overcast days are best. Midsummer is generally the optimal time for photography here.

Walla Walla Valley Chamber of Commerce: 509-525-0850; www.wwvchamber.com

41. Whitman Mission National Historic Site

Located a short drive east of Walla Walla on U.S. 12 is one of the state's most historic sites. Narcissa and John Whitman arrived as early pioneers to the area and established a mission to convert local Native Americans to Christianity. Narcissa's accounts of the time are poignant and talk of trouble with the Natives. Her narrative might hold the secret as to why the Whitmans, along with others, were massacred at the mission site in 1843.

Photographing here is challenging and emotional. Evening light is special; however, both morning and evening work when the site is less crowded. Use surrounding vegetation or natural foregrounds to add additional interest to your images. There is a small museum at the site where we use existing light with white-balance correction.

Whitman Mission National Historic Site: 509-529-2761; www.parks.wa.gov

42. Lower Granite Dam

WA 193, just outside Clarkston, weaves through beautiful farm country on its way to Lower Granite Dam. The route follows the Snake River Canyon before climbing to farmland above.

Early morning, when the light is low, is a wonderful time inside the canyon. Warm light reflects off towering bluffs and paints the big river with a golden glow.

Explore several different angles of the same shot. Expose each for later review.

Along the route to Lower Granite Lake there is plenty to photograph, from colorful landscapes to pastoral scenes.

Early spring and midsummer, when heavy clouds roof the area, are our favorite times here. The area is especially picturesque when evening approaches sunset and long shadows dominate the rolling landscape. A few miles west of the dam there is a nice sand dune area that provides a great foreground for canyon shots.

Beyond the dunes, the road climbs back to the surrounding farm country, offering additional vantage points for sunset shots. If there are large clouds in the sky over this area, we usually take our time and make sure to find a good spot from which to capture the setting sun.

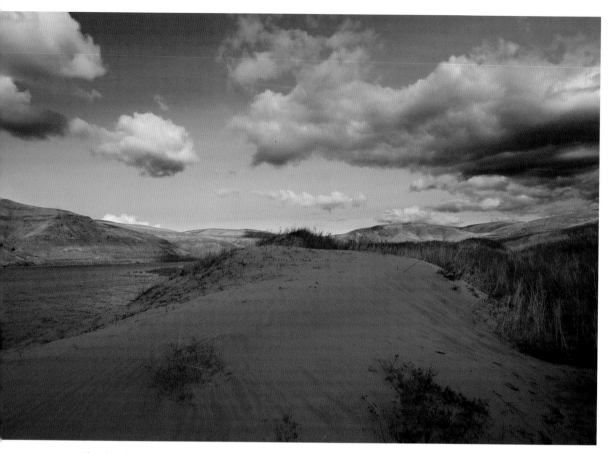

Clouds add an atmospheric punch to landscape images. Polarize the sky if necessary.

The roadway ends at the farming town of Pomeroy.

Washington Tourism Alliance: www.experiencewa.com

43. Yakima Fruit Country

Washington is dubbed the Evergreen State not only due to its dense forests and high mountain meadows—the name also comes from its abundant farm country. Yakima rests at the heart of farm country, and boasts fruit ranging from delicious peaches and apples to some of the best grapes found anywhere. You can't travel too far in the valley without coming across a fruit stand, lush field, or quaint winery.

The photographic story here is all about farming, and the long days leading up to harvest. Entire photographic books have been published on this fascinating subject. We tend to favor close-up and midrange images in Yakima's vineyards and orchards. We commonly use macro lenses for some of this photography. They range between 55mm and 100mm. Polarizing filters also come in handy to remove glare from fruit such as apples and grapes and intensify color. Morning dew or water from sprinklers can add a compelling element to close-ups.

Greater Yakima Chamber of Commerce: 509-248-2021; www.yakima.org

44. Yakima River Canyon Scenic Byway

While traveling through Yakima, take note that there is an alternate route back to I-90 from the valley. It is WA 821, and it runs along the Yakima River.

Listed as one of Washington's scenic byways, the route weaves through a steep canyon filled with exciting places to put your camera to work. The canyon is composed of arid terrain worn to bedrock in some places by the relentless work of erosion. We like to photograph the canyon in early spring, when trees along the river turn a lime green and the water level is moderately high. Autumn is also a great time to photograph here.

Due to the steep topography inside the canyon, it takes a long time for sunlight to reach the bottom and the river. The morning, as you might expect, is our favorite time here, and very often we use a couple of stops of graduated neutral density just to balance scenes out.

Washington Tourism Alliance: www.experiencewa.com/things-to-do/ scenic-byways

45. White Pass Scenic Byway

White Pass Scenic Byway, US 12, cuts through interesting country as it follows the Tieton River west into the high mountains. Along the way, it passes Tieton Dam. The byway travels through arid cliff country and then dense forests as it gains elevation.

Spring or fall, when deciduous color is at its peak, are both nice times for photography here. The colorful trees provide a pleasant foreground for the steep basalt cliffs. We travel slowly along this highway because there is also plenty of wildlife in the area, including elk and bighorn sheep. There is even a wildlife management area along the road where you might want to spend some time.

The byway skirts William O. Douglas Wilderness to the north and Goat Rocks Wilderness to the south. Trailheads for both areas are provided.

Washington Tourism Alliance: www.experiencewa.com/things-to-do/ scenic-byways

46. White Pass

White Pass, U.S. 12, provides a great southern entrance to Mount Rainier National Park and is our usual route to the park in winter and

Two-stop neutral-density filtration balances an early-morning canyon scene.

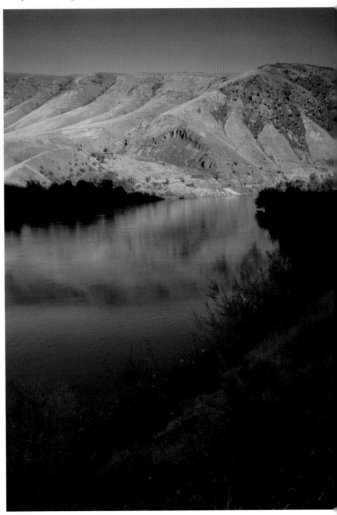

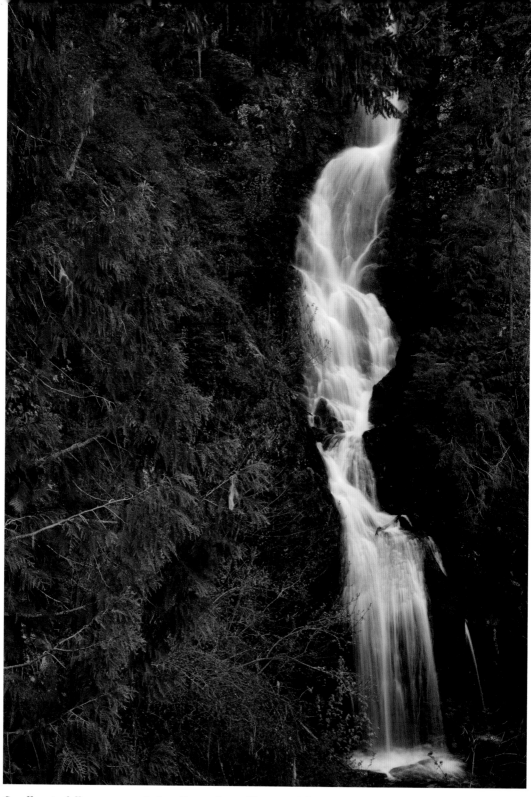

Small waterfalls are seasonal along the roadway. Many vanish as spring wanes.

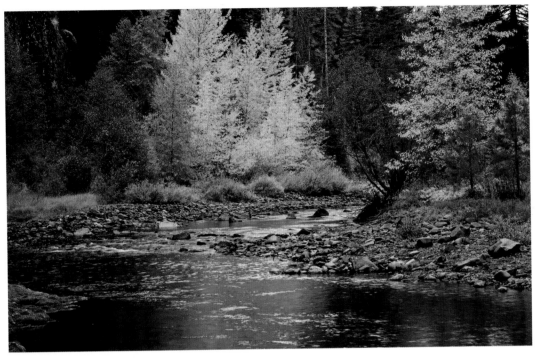

The Little Naches River is one of our favorite subjects in autumn.

early spring, before WA 410 and Chinook Pass open. Spring waterfalls also appear in the area of the pass, which makes it an even more rewarding roadway.

One thing you might keep in mind as you travel this area: A waterfall that laterally gushes during spring may dry up as the heat of summer comes. So take advantage of them when they are flowing.

Washington Tourism Alliance: www.experiencewa.com/things-to-do/ scenic-byways

47. Chinook Pass Scenic Byway

Almost every time we travel Chinook Pass Scenic Byway, WA 410, it takes a lot longer than we'd expected. Along the way, the Naches River and the Little Naches River and the colorful vegetation along their banks provide ample distraction.

The area is especially photogenic in October, when color is at its best. At this point, it might be helpful to talk about autumn photography along streams. We like to emphasize both color and flow in many of our autumn stream shots. To attain this, we move in close on a colorful bush or grass and make sure we have plenty of depth of field to reach the background or flowing water. The stillness of foreground will determine the necessary shutter speed. If everything is still, which it usually is in morning, we concentrate on allowing the background water to flow past the lens with a slow shutter speed, 1/15th to 1/6th of a second. The ribbon-like flow in the background adds further emphasis to the razor-sharp, colorful foreground. The elements complement each other. Try it!

Chinook Pass Scenic Byway: http://chinookscenicbyway.com

Tripods are an important part of our gear. They slow us down and lead to stronger compositions.

48. Chinook Pass

Chinook Pass summits at 5,430 feet, and over-looks parts of the William O. Douglas Wilder-ness to the south. Mornings are especially stunning and absolutely wonderful for photog-raphy at this elevation.

A short distance from the canyon overlook, the highway passes under a prominent foot-bridge. Here the Pacific Crest Trail crosses and weaves through the wild Cascades. The north side of the trail passes through Norse Peak Wilderness, while the south threads through William O. Douglas Wilderness and finally Goat Rocks Wilderness farther south.

Needless to say, this is a truly wild junction, and it's worth spending time here if moun-tain photography is your objective. West of the bridge you'll find the boundary of Mount Rainier National Park. Plan your arrival in this area before first light; you won't regret it.

Chinook Pass Scenic Byway:
http://chinookscenicbyway.com

49. Klickitat Wild and Scenic River

Much of the lower section of the Klickitat River, from Lyle on Highway 14 north to Pitt, is federally designated as a Wild and Scenic River. Along its course this wild little river cas-cades through steep-sided ravines and narrow chasms, providing some great photographic opportunities.

WA 142 parallels the river for approxi-mately 15 miles and crosses it twice. Along the Klickitat there are a number of vantage points from which to photograph, including bridges. There is also a great trail open to hiking and

biking that runs for 31 miles from Lyle to Goldendale. The Klickitat River finds its origins high on the eastern slopes of Mt. Adams and runs fairly strong year-round.

We like to add a sense of contrast to spring river shots by letting fast rapids flow past a slow shutter, at 1/15th to 1/6th of a second. Be careful of movement in surrounding vegetation, however.

Mt. Adams Chamber of Commerce: 509-493-3630

Klickitat Trail Conservancy: www.klickitat-trail.org

50. White Salmon Wild and Scenic River

Located a short 10 miles west of the Klickitat River on WA 14 is another Wild and Scenic River, the White Salmon. It is accessible from WA 141, which travels north to Trout Lake.

There are a number of nice places along the route to photograph. However, because of private property along the river, it is far less accessible than the Klickitat River.

Southwest Washington Visitors Bureau: 360-750-1553

Visit Vancouver USA: www.southwestwashington.com

51. Little White Salmon River

Farther west on WA 14 you'll find the Little White Salmon River and National Fish Hatchery. Early morning on this short stretch of river is spectacular.

Southwest Washington Visitors Bureau: 360-750-1553

Visit Vancouver USA: www.southwestwashington.com

Slow shutter speed allows flowing water to blend.

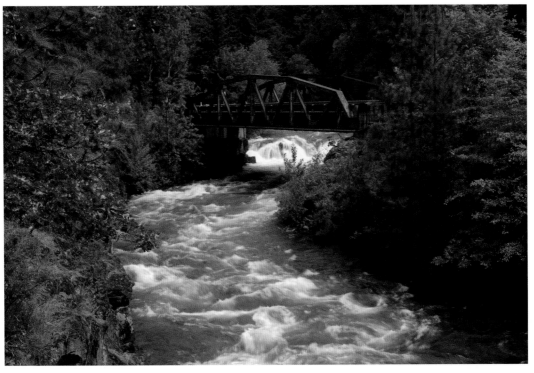

On each outing, take the time for careful exploration; engage your photographic eye.

III. The Northwest Mountains and Valleys

As discussed earlier, all of Washington, including the magnificent mountains and valley west of the plains, joined the mainland after the splitting of the ancient continent. So the entire landmass, from the present west coast to the "Old West Coast" in western Idaho, is relatively new. As a matter of fact, regardless of their stately demeanor, the rugged coastal mountains and fertile valleys of western Washington are youngsters, geologically speaking.

Remarkably, the Cascade Range, as it separates east from west, remains unsettled as tremendous pressure and convection from deep within the earth continue to push the mountains upward, while other natural forces on the surface, such as glaciation, mass wasting, and erosion, continually carve away at prominent peaks. It might be said, as we look at the geographic world around northwestern Washington, that everything we see is working to be something else: plant life eventually turns to soil, fresh water flows to the ocean, and huge mountains eventually crumble under the force of water and ice.

Understanding even the most basic cycles of nature and the world around us can help us take more meaningful and better pictures.

52. North Cascades Scenic Highway, North Cascades National Park

Few highways in America can top the North Cascades Scenic Highway, WA 20, for its beauty and photographic access.

The roadway enters North Cascades National Park just east of Ross Lake National Recreation Area, but not before weaving alongside Granite Creek and Ruby Creek for a fair distance outside the park's eastern boundary.

Both creeks offer a wonderful array of midrange pictures and can be accessed via a number of trailheads along the road.

Entering North Cascades National Park from the east, you'll find broad mountain vistas including the glacial water of Ross and Diablo Lakes. Keep in mind as you travel through North Cascades, this range ranks as one of the most glaciated areas in the nation. Shortly after entering the park, the highway parallels the Ruby Arm of Ross Lake, overlooked by the Sourdough Mountains to the north. We like to be in this area at sunset or sunrise for wild skies that cling tightly to surrounding peaks.

There are plenty of overlooks and pull-offs in the area providing shots of both Ross Lake and Diablo Lake, farther west. There are also a number of trails leading deeper into the backcountry for a closer view of the mountains. Some of the best shots we get during a trip to this side of the North Cascades result from our exploration of roadside trails and scoping out what time is best for the scenes they provide. Don't miss Happy Creek Forest Walk, well signed along WA 20 on the left side. We always take at least two or three days to explore different areas on this side of the park, and use designated campgrounds as our home base. Late spring, when streams are gushing and mountain runoff feeds smaller waterfalls, is our preferred time to travel here.

We use a variety of techniques in this part of the park, especially on water images. One of our favorite strategies is to shoot streams early in the morning when they are still in shade. Occasionally, we add a stop or more of neutral density, decreasing shutter speed even more, 1/6th of a second or less. If you do this remember to focus on something large and detailed

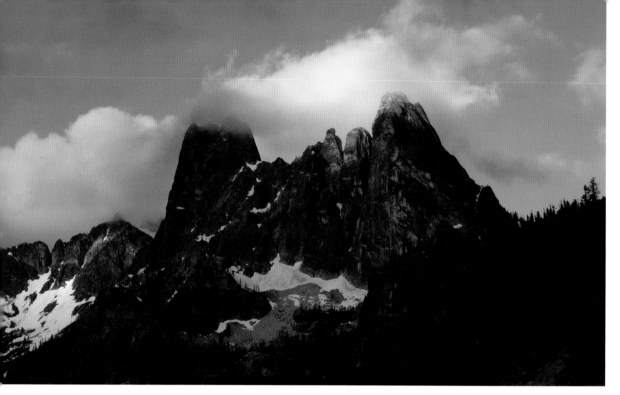

Early-winter spires catch the morning light.

inside the scene to give it a clear focus point—a colorful rock, for example.

Washington Tourism Alliance:
www.experiencewa.com

53. Ross Lake National Recreation Area

The shoreline of Ross Lake requires some fairly long hikes, heading north of the highway. We usually plan day hikes here, and more times than not, divert from the main trail to explore and photograph different scenes.

When we pack photographic gear for these hikes, we decide first what type of shots we are after: large vistas from high passes, short or midrange images, or various foregrounds for surrounding mountains. The gear we pack is for the shots we identify. We include filters and lenses for those specific images only, but never leave the tripod behind. Oftentimes we are heading for a mountain pass, and set out early

to arrive at a choice location in good morning light.

North Cascades National Park:
360-854-7200; www.nps.gov.noca

54. Diablo Lake Overlook

The Diablo Lake overlook consists of a very large, busy parking lot situated on the ridge above Diablo Lake. The best time to arrive here is shortly after sunrise, when the parking lot is empty and the light is wonderful.

Several prominent mountains rise beyond the lake and normally glow in early-morning light. Alpenglow, that ruby blush that appears just prior to sunrise, is common here, especially in early spring when the mountains still retain snow. Diablo Lake itself, due to the influence of glacial water, takes on a teal-blue tint especially in morning light. This is the best place to catch it. It is worth hanging around

here long enough for the light to recede lower in the canyon or even reach the immediate foreground just below the overlook.

While photographing Diablo Lake, be sure to glance behind you at the Sourdough Mountains, particularly at sunrise.

North Cascades National Park: 360-854-7200; www.nps.gov.noca

55. Pacific Crest and Pacific Northwest Trails

Remember as you plan a photographic trip to North Cascades National Park that 94 percent of the park and much of the national forest surrounding it is federally designated wilderness; consequently, hiking is a huge part of the experience.

Two wonderful trail systems bisect the North Cascades National Park, and each should figure into your photographic plans. The Pacific Crest Trail winds through 20 miles of the park, and the lesser-known, but equally beautiful, Pacific Northwest Trail travels a total of 60 miles inside the park from Lightning Creek to Hannegan Pass. This remarkable trail system is 1,200 miles in length and travels from Montana's Glacier National Park to Cape Alava in the coastal regions of Olympic National Park. For photographers, both trails offer access to tremendous backcountry sites.

Pacific Crest Trail Association: 916-349-2109, www.pcta.org

Pacific Northwest Trail: www.pnt.org

Don't limit yourself to "iconic" shots: spend time, observe your surroundings, and follow your photographic eye.

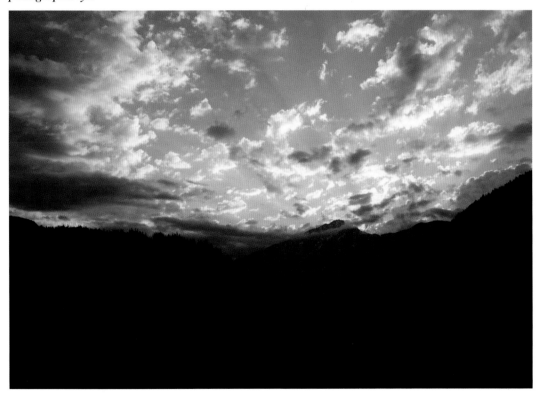

56. Newhalem

The North Cascades Visitor Center is located in the quaint town of Newhalem, which is a good place to stop to familiarize yourself with North Cascades National Park. As an added photographic reward, a short half-mile hike from Newhalem's city park will take you to

The perfect spot is sometimes just off the trail.

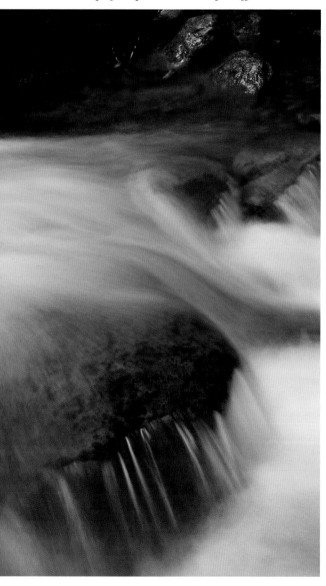

Ladder Creek Falls. Plan to photograph the falls early in the morning or in late afternoon, to avoid the distracting influence of bright sunlight.

Adjust your camera's white balance for shaded light, and dial in a slow shutter speed and an aperture with plenty of depth (F-16 to -22). Lock your camera on a tripod and allow the falls to flow past the lens. The next step is very important. Don't just compose a single shot and leave it at that. Instead, push your compositional eye while searching for the very best image of the falls. Lower your angle, quicken your shutter speed, use a close-up foreground—have fun with it.

North Cascades Visitor Center: 206-386-4495, ext. 11

57. Skagit River Bald Eagle Natural Area

Leaving North Cascades National Park on WA 20, you travel along the Skagit River, a noted site for bald eagles and a variety of other wildlife.

The river maintains a vibrant winter salmon run and attracts one of the nation's largest concentration of bald eagles. Located on WA 520 just south of Rockport, you'll find one of Washington's best-kept secrets for wild-bird photography: the Skagit River Bald Eagle Natural Area. To fully enjoy the area as a photographer, we recommend familiarizing yourself with both the surrounding habitat and eagle movement throughout the area. Getting to know the lay of the land, so to speak, increases your chances of bagging that special shot. Using this tactic, it might not be necessary to lug around a huge 600mm lens.

At the Rockport Fire Hall, you'll find information on seasonal programs and guided walks.

Skagit River Bald Eagle Interpretive Center: 360-853-7626; www.skagiteagle.org

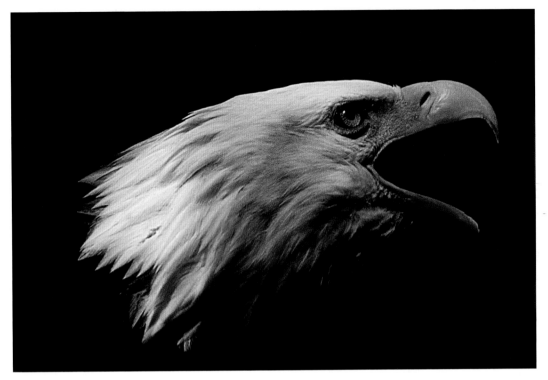

As you process images, consider a few for black-and-white conversion.

58. Skagit Eagle Festival

Each winter, the town of Rockport plays host to the Skagit Eagle Festival; if you enjoy photographing birds, you definitely won't want to miss it.

Most of the events surrounding the January festival occur at the Skagit River Bald Eagle Interpretive Center, located at Howard Miller Steelhead Park, south of WA 20. There you will be treated to guided tours, photography workshops, and live bald-eagle demonstrations. An added attraction is performances by Native American dancers and musicians whose culture revolves around wild eagles and their return each year in a celebration of life and time.

Skagit River Bald Eagle Interpretive Center: 360-853-7626; www.skagiteagle.org

59. Mount Baker Wilderness

Resting to the west of North Cascades National Park is the Mount Baker Wilderness, which is bisected by WA 542, one of the most beautiful roads in the Pacific Northwest.

On its way to Mt. Baker Ski Area, Heather Meadows, and other great attractions, the road ascends through heavily timbered forests crisscrossed by hundreds of streams, large and small. WA 542 in its entirety is a favorite destination of ours for photography, for both typical forest and stream images and striking panoramic landscapes of snow-covered peaks, deep-cut valleys, and wild climatic conditions over the mountains.

At the end of the road a special treat awaits, Heather Meadows and an overview of Mount Baker. Best time here is mid to late summer, when the meadows are alive with wildflowers.

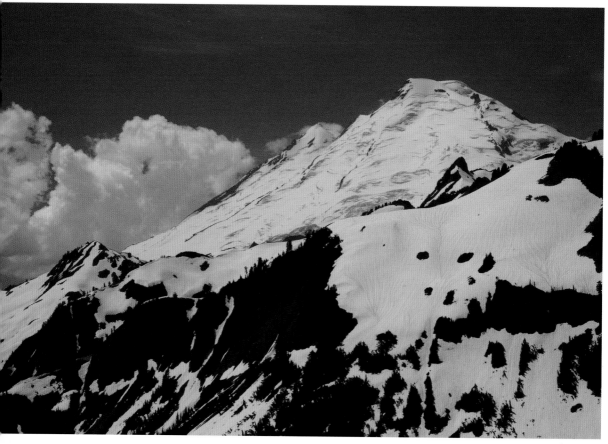

From a distance, wilderness areas take on a painterly quality.

What makes WA 542 really special is that, because of the busy ski area, the road is open all winter, providing photographers with exceptional opportunities to take great mountain images at higher elevations.

U.S. Forest Service, Mt. Baker-Snoqualmie National Forest: 425-775-9702 or 800-627-0062; www.fs.fed.us/r6/mbs

60. Nooksack Falls

Nooksack Falls is located just off WA 542, midway between Glacier and Silver Fir Campground. A parking lot for the falls is clearly marked on the right side of the road. Impressively, Nooksack Falls actually splits into two waterfalls immediately before it thunders to the deep valley below. There are a number of viewpoints for the falls that are surround by a rather tall fence. For best results, use a tripod that extends to six feet to clear the barrier.

The Nooksack River drains a vast terrain above the falls, so heavy flow can be expected during spring runoff. It's best to catch the falls later in the summer, or even late fall when water level is down. Because of the angle of the sun and thick forest canopy, we find morning is best for photography here; however, the diffused light takes both an adjustment in white balance to the warm side and a slow shutter speed or increase in ISO. Extremely slow shutter speeds

are not advised, simply due to the large amount of water cascading over Nooksack Falls. Here we opt to go with an increased ISO, sometimes 800, for the right result.

U.S. Forest Service, Mt. Baker-Snoqualmie National Forest: 425-775-9702 or 800-627-0062; www.fs.fed.us/r6/mbs

61. Mount Shuksan in Winter

WA 542, as it begins its final steep climb to Mt. Baker Ski Area, is a great place for winter shots of 9,127-foot Mount Shuksan. The two pull-offs above White Salmon Ski Area are especially good vantage points. For best results, try to arrive long before sunrise and wait for the color show to begin. Before making the trip, however, be sure you have a few open days weather-wise. Most winter mornings in this area begin with thick cloud cover. What is important for images of Mount Shuksan is how fast the cloud cover burns off or brightens.

When the light is right, mornings at this elevation will simply kidnap your photographic imagination. A jagged wall of mountains separating Washington from Canada rise to the north of the highway and make spectacular pictures themselves. A polarizing filter on bright winter days will add pleasing depth to sky and clouds.

U.S. Forest Service, Mt. Baker-Snoqualmie National Forest: 425-775-9702 or 800-627-0062; www.fs.fed.us/r6/mbs

High mountains create weather, especially in winter. Isolate shots with a longer lens.

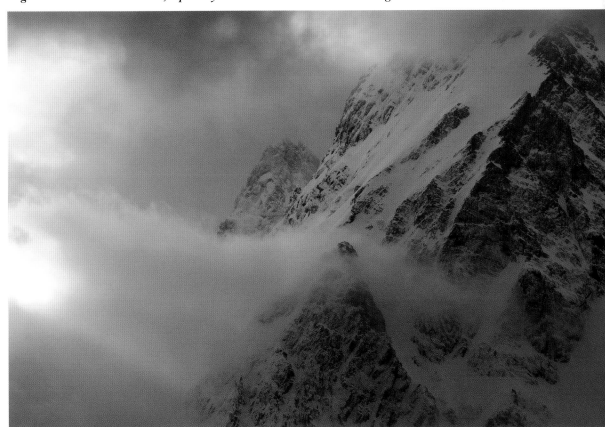

62. Mount Baker–Snoqualmie National Forest

For further winter access to Mount Baker–Snoqualmie National Forest, consider the Nordic Park across from Silver Fir Campground on WA 542. A National Forest Recreation Permit is required to park at the area and use the cross-country trails, but it is well worth the investment.

In winter the terrain around Mounts Baker and Shuksan receives world-record snowfall, which incidentally measured an unbelievable 1,140 inches in 1998–99. With that much snow, the Nordic Park is a virtual winter wonderland. We suggest cross-country skies, a light pack, and plenty of time to photograph this area. Be advised: campgrounds are closed in winter.

The Nordic Park in summer turns into a hiker's paradise and accesses some truly wild country affording a wealth of photographic opportunities. Winter, however, is our favorite time here.

U.S. Forest Service, Mt. Baker-Snoqualmie National Forest: 425-775-9702 or 800-627-0062; www.fs.fed.us/r6/mbs

63. Mount Shuksan from Picture Lake

Below the parking lot at Mt. Baker Ski Area, you'll find Picture Lakes located on either side of the road. Seasonally these provide a nice

No two natural elements go better together than mountains and clouds. A polarizing filter enhances the effect.

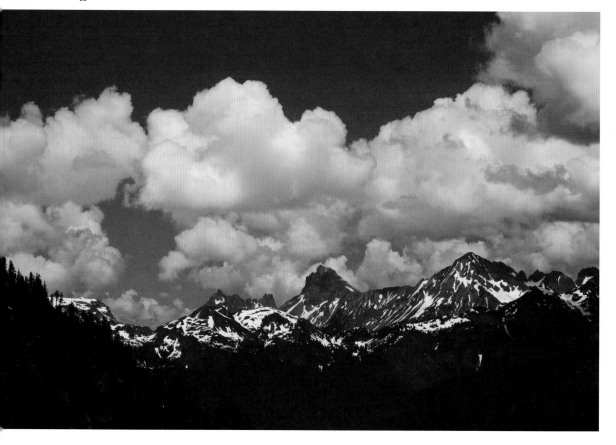

foreground for Mt. Shuksan. Arrive at the right time, and a magnificent reflection of Mount Shuksan is mirrored on both lakes. Spend enough time in this area to get exactly what you want. We find the reflection is best on a calm afternoon given the sun's western axis. Sunrise and early morning here can also be good but will generally require either graduated-neutral-density filters or HDR.

Another thing we have found when shooting mountain reflections: it is easy to be overwhelmed by the sheer visual impact of these scenes. So take it slow and remember to include a touch of surroundings, a bank of bushes, or grove of trees to add dimension. After you get the image you came for, push your skills by composing different shots, silhouetting parts of the foreground as a frame around the colorful focal point, for example.

U.S. Forest Service, Mt. Baker-Snoqualmie National Forest: 425-775-9702 or 800-627-0062; www.fs.fed.us/r6/mbs

64. Mount Baker and Heather Meadows

Photographers who have their eye on those iconic shots of 10,781-foot Mount Baker surrounded by colorful wildflowers usually start to show up at Heather Meadows toward the middle of August and stay until everything is just right. Mount Baker from Heather Meadows is one of Washington's most recognizable shots and is generally duplicated hundreds of times each wildflower season. The trick in a place like this is to come away with something different, and given the amount of notoriety the meadows has that is a difficult task. We smile each time we're able to get a different image of a recognizable scene, and will go a long way to capture something unique.

The first trick is to arrive when wildflowers are at their peak, and the best way we have found to do that is to make a few phone calls in advance. Besides the Forest Service offices located

Take the effort to isolate small scenes, especially at iconic sites like Heather Meadows.

in Glacier, there are a number of lodges whose staffs are generally very helpful with regard to local information; Glacier Guest Suites (360-599-2927), the Inn at Mount Baker (360-599-1776), and Ptarmigan Inn (360 303-7742) are all good contacts. We generally call and inquire about local conditions and plain accordingly.

U.S. Forest Service, Mt. Baker-Snoqualmie National Forest: 425-775-9702 or 800-627-0062; www.fs.fed.us/r6/mbs

65. Skagit Valley

Skagit County is the product of rich volcanic soil laid in place millions of years ago, and it offers a whole array of wonderful agricultural scenes. Photographs here range from historic buildings rising before the Cascade Mountains, outdated farm machinery rusting in coastal fog, and colorful fields of tulips. Few places in Washington offer a better setting for this type of photography than Skagit Valley on WA 20, east of Mount Vernon. An added attraction is the historic town of La Conner.

For a true Washington photographic experience, this area is a must for a number of reasons,

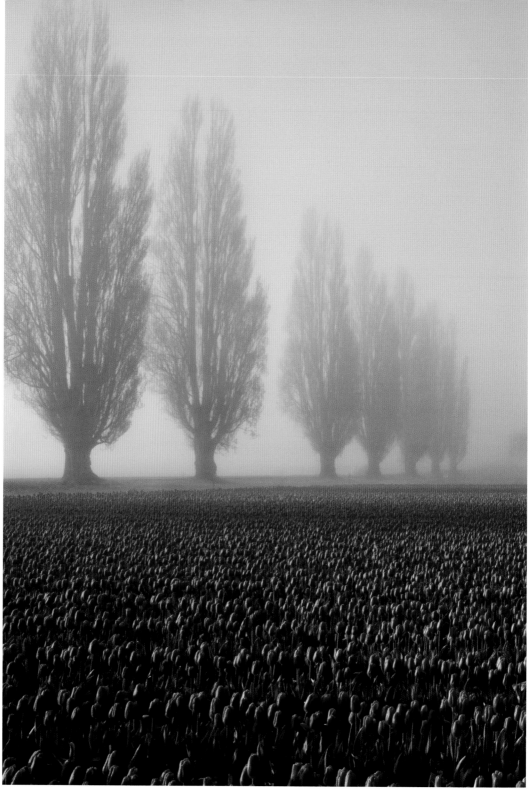

Shoot both vertical and horizontal images. Add variety to your collection.

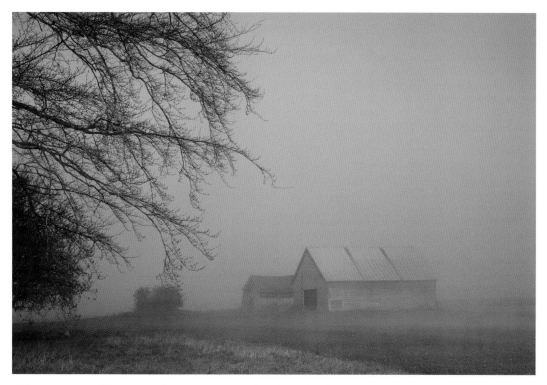

Take advantage of foggy mornings to convey mood and emotion in your shots.

including its closeness to the coast, farming history, and the frequent fog cover that adds intrigue to pastoral scenes. We like to shoot the valley in mid-May when everything is greening up and fog greets most mornings. A simple natural element like fog can quickly transform a good pastoral scene into a great one.

La Conner Chamber of Commerce: 360-466-4778; www.lovelaconner.com

66. Skagit Valley Tulip Festival

The Skagit Valley Tulip Festival, with its vivid palette of color set against the Cascade Mountains, is another Washington iconic scene and a blast to photograph. The festival begins the first of April and runs the entire month, with community activities one after another.

For the photographer, it is the bloom of colorful tulips that's the main attraction. The

valley west of Mount Vernon is the best place to capture that special tulip shot. You enter the valley via WA 536, where signs clearly mark the tulip route. Two farms we highly recommend are Skagit Valley Bulb Farm (Tulip Town) on Bradshaw Road, and Washington Bulb Company's Roozengaarde. The Roozengaarde site is our favorite. The best time for us is around the middle of April when tulips are in full bloom, just prior to picking. Both locations are active bulb farms and in order to produce bulbs, the blooms are picked at certain times.

The festival requires a bit of coordinating, but there are plenty of numbers to call for current information including the ones below. Because this is an iconic shot, we try for something different each time we go. Morning usually works best for us; foggy days and low evening light are also special.

Skagit Valley Bulb Farm: 360-424-8152, www.tuliptown.com

Skagit Valley Tulip Festival: 360-428-5959, www.tulipfestival.org.

67. Bird Photography in Skagit Valley

In winter, the Skagit Valley removes its pastoral garb and dons feathers. By all accounts, the Skagit Valley is nothing short of fantastic for bird-watching and photography, and none know it better than Skagit Audubon Society. Here is the society's list of sites and times for prime bird photography:

Samish Flats, Padilla Bay, and Alice Bay. Best fall to spring for raptors, waterfowl, and passerines.

Skagit Flats on Fir Island. Best fall to spring for snow geese, trumpeter and tundra swans, and raptors.

Bird photography takes time and plenty of patience.

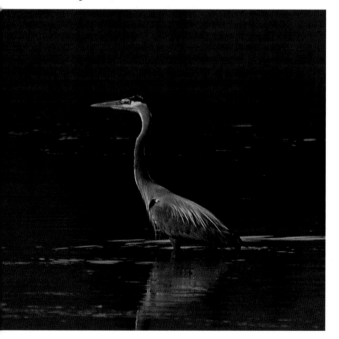

Skagit Bay–Skagit Wildlife Area. Many species in Wylie Slough Area, using the Jensen and North Fork Access in particular.

Washington Park outside Anacortes. Best fall through spring for seabirds.

Padilla Bay National Estuarine Research Reserve on Padilla Bay. Best in spring.

Eagles and raptors abound in the valley, but require a longer lens and plenty of patience. From our perspective a longer lens is helpful but not absolutely necessary. Think of this: while an expensive 600mm will render a full-frame shot of an individual bird, a less costly 300mm will produce a very nice environmental shot with birds emphasized. A nice environmental shot including certain bird species like bald eagles will sell two to one over a full-frame headshot of the same species. Food for thought.

Audubon Washington: 206-652-2444; www.wa.audubon.org

68. Bow Area

For a great day among birds ranging from timid short birds to soaring bald eagles, try the coastal area and mud flats around the small town of Bow accessed via WA 11, or north from WA 20 in the area of Bay View State Park. These areas will definitely surprise you!

Washington Tourism Alliance: www.experiencewa.com

69. Anacortes and Loop Drive

The coastal town of Anacortes by itself is worth the drive from Mount Vernon, especially if you're in the area for the Tulip Festival. Not only does Anacortes offer a short ferry ride to the San Juan Islands but it has a coastal character all its own.

One of the prime locations we've discovered here is Loop Drive, found on the west

The Loop Drive offers access to intriguing coastal scenes.

Here a strong foreground creates a more powerful image.

or coastal side of town. For general directions to the drive follow the same route for the San Juan Islands ferry. After passing the ferry turn-off, watch for signs leading to the drive as you continue west.

Loop Drive is a local treasure that will inspire your creative muse. Wonderful and unusual coastal scenes appear in tandem with plenty of access by way of pull-offs seemingly designed for photography.

Evening with low western sun is a special time on the Loop. One of Washington's most photographed trees is found on the drive.

Anacortes Chamber of Commerce: 360-293-7911; www.anacortes.org

70. Deception Pass State Park

North of the town of Oak Harbor on WA 20 you'll find Deception Pass State Park, along with its prominent bridge spanning the water below. The park boasts 16 miles of hiking and biking trails, and there is plenty to photograph here. We like the view from far below the bridge.

Washington State Parks: 360-902-8844; www.parks.wa.gov

71. Rhododendron Species Botanical Garden

Driving south on Interstate 5, there are a couple of sites in Federal Way you'll want to photograph. The Rhododendron Species Founda-

tion maintains a wonderful rhododendron garden at the Weyerhaeuser Company's headquarters in Federal Way. If rhododendrons are on your list of favorite flowers, here is the place to capture them at their best.

The gardens are well maintained and emphasize the natural setting in which these beautiful flowers are commonly found. Something to keep in mind, however: rhododendrons are early bloomers, usually in April and May. It is helpful to call ahead to determine the peak time to photograph. After rhododendron blooming season is over, you can still enjoy many other plants indigenous to the Pacific Northwest that are featured here.

Rhododendron Species Botanical Garden: 253-838-4646; www.rhodygarden.org

72. Pacific Rim Bonsai Collection

The Pacific Rim Bonsai Collection is located near the Rhododendron Species Botanical Garden on the Weyerhaeuser campus in Federal Way. This is one of the foremost bonsai collections in the nation and includes 60 trees.

We generally arrive with a tripod and electronic release, and try for an overcast morning when the light is uniformly balanced. Each specimen in the collection is surrounded by a separation ribbon, so bring along a small telephoto (100mm) or 80 to 200 zoom. A bit of advice that comes from our first visit to the collection: While shooting individual bonsai trees, by all means record the descriptive information on the accompanying plaques. This is great information once you begin to work on your files.

Rhododendron Species Botanical Garden: 253-661-9377; www.rhodygarden.org

73. Wallace Falls State Park

Interstate 90 tops out at Snoqualmie Pass and descends the west-facing slope of the mountains before finally reaching Seattle. Wallace Falls State Park, located a few miles north of Gold Bar on US 2, is a very special site on the east side of the pass that should not be missed.

A nicely maintained trail leaves the parking lot, and in 2.7 miles arrives at Upper Wallace Falls. Along the route you pass Small Falls and Middle Falls, both worth a stop. The lower section of the trail also follows the Wallace

Plan to visit when flowers are at peak bloom.

River, itself a wonderful subject to photograph. The river's western bank is littered with large moss-covered boulders, which provide a great foreground for larger shots. Morning, when the sun's light has not yet reached the river and falls, is best.

Small Falls is particularly interesting in late spring for both detail and access. We often shoot from a low angle at places like Small Falls, letting the foreground detail enhance the picture. If your foreground is going to include boulders or bedrock, here's a great tip: Splash water across the rock to provide a more detailed effect. We carry a small folding cup for just this purpose.

Washington State Parks: 360-902-8844; www.parks.wa.gov

74. Snoqualmie Pass

Interstate 90 rises to 3,322 feet above sea level at Snoqualmie Pass before starting a quick descent to Seattle. Along the route, on both sides of the pass there are plenty of spots to pull over and photograph. If you are a waterfall enthusiast, a number of nice falls are located in the area, especially on Denny Creek. The road to Denny Creek can be found at Snoqualmie Pass Recreation Area (exits 47 or 52) leading to Denny Creek Campground. Trails from the campground lead to Keekwulee, Snowshoe,

Reflected colors deepen on overcast days.

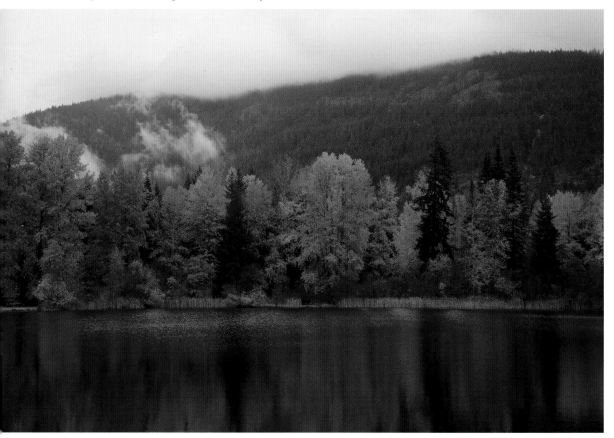

and Franklin Falls. In spring and early summer, smaller roadside falls can make great subjects.

Autumn is also a special time to drive the pass, with Kachess and Cle Elum Lakes reflecting autumn color on the east side, and Snoqualmie Falls on the west. Slow down and watch the light. In our experience, photographers can miss great shots in their haste to get to the next well-known location. Don't let a prize shot fly by while you're rushing to the next iconic spot.

Washington Tourism Alliance:
www.experiencewa.com

75. Snoqualmie Falls

Snoqualmie Falls is a good place to work on putting your own stamp on an image, simply because, given its closeness to I-90 and Seattle, it gets plenty of attention from photographers.

While the falls are truly spectacular from the lower trail, in our opinion they are just as powerful from viewpoints on top. Waterfall images, like sunsets, oftentimes need a little added punch to make them truly special. More times than not, a beautiful falls lacks dimension, which in most cases is part of its attraction. Snoqualmie Falls is a perfect example. Part of its sheer impact is its size and power. To emphasize physical size, we recommend including some environmental elements as points of comparison or reference.

Our favorite time to shoot this falls is the height of autumn, when the surrounding landscape is colorful and cooling mountain air brings valley fog.

Washington Tourism Alliance:
www.experiencewa.com

76. Seattle

It's hard to list all the opportunities awaiting photographers in the city of Seattle—there are simply too many. When we visit Seattle with camera in hand, we tend to approach it in small

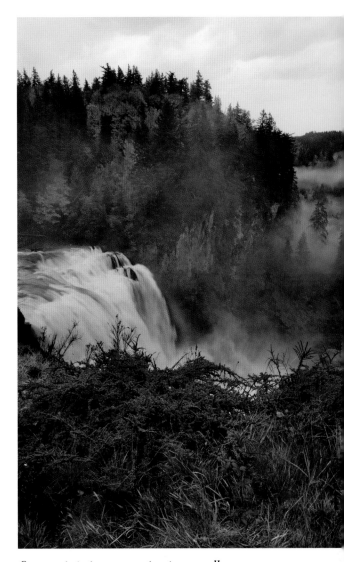

One way to put your own stamp on a well-frequented site is by finding an interesting viewpoint.

bites. For example, we might pursue the Space Needle one day and turn our attention to the zoo and aquarium the next, while Pike Place Market waits in the wings. Our best advice? Take plenty of time and plan carefully.

Seattle Southside Visitor Information:
877-885-9452; www.seattlesouthside.com

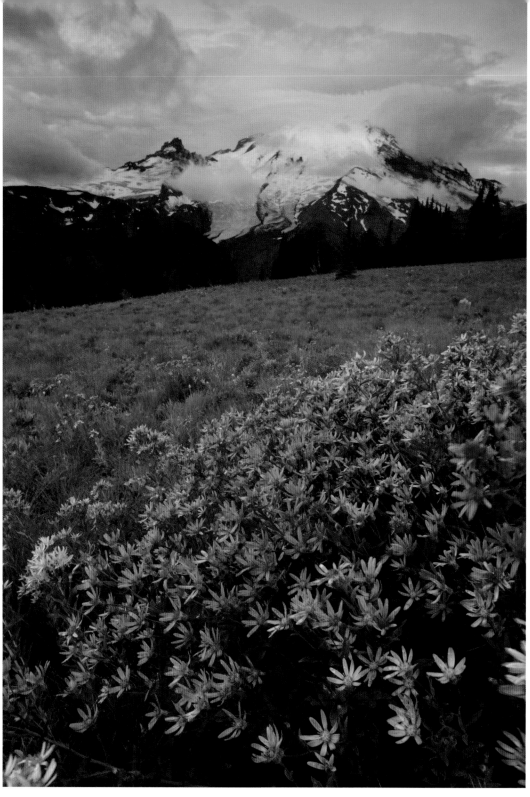

Well-balanced mountain shots include interesting foregrounds, cloud cover, and exceptional scenery.

IV. The Southwest Ring of Fire

The catastrophic events that advanced its geologic history keep the Pacific Northwest region in a state of constant change.

Washington is home to five active volcanoes: Glacier Peak, Mount Baker, Rainier, Mount Adams, and Mount St. Helens, all youngsters in geologic time. Eleven others extend through the Cascade Range and into Oregon and California.

While Mount St. Helens last erupted in 1980, the others have been quiet for thousands of years: Mount Rainier last erupted 2,500 years ago; Mount Adams blew its lid 3,500 years ago; while Glacier Peak last erupted 11,200 years ago. Regardless of their history, each of these beautiful mountains breaks the horizon and with a sense of stability, brought on by size and splendor alone, to greet each new day. What tomorrow will bring is anyone's guess.

77. Point Defiance Park

The 702-acre Point Defiance Park, located at 5400 North Pearl Street, Tacoma, offers a number of attractions, including the Point Defiance Zoo and Aquarium, a replica of Fort Nisqually, and even a logging museum. Our primary points of interest, however, are the nature trails and 5-mile auto loop, which provide access to both beach and the natural forest.

Equally pleasing for photography are the amazing gardens at Point Defiance. Autumn in the gardens is outstanding. The Japanese garden in full color is our favorite, peaking in early October.

This is a city park, and photographing in crowded locations takes patience, but can be truly rewarding. For both the wooded areas and gardens, soft light works best. Morning overcast is wonderful for warm color saturation. The trails, drive, and gardens are open from sunrise to a half hour after sunset.

Point Defiance Park, (253) 305-1000; www.metroparkstacoma.org

78. Lakewold Gardens

The beautiful Lakewold Gardens was the lifelong passion of Eulalie Wagner, who with her husband purchased the estate in 1925. Originally built in 1914 on 10 secluded acres, the estate features captivating views of Mount Rainier and Gravelly Lake. The Wagners employed famous landscape architect Thomas Church to turn the grounds into a picture-perfect property.

Color and contrast frame the Lakewold Buddha.

Catching the Canadian lynx in midstep adds a sense of motion.

Surrounding the Georgian Revival mansion are rose, rock, and woodland gardens as well as an intriguing knot garden. Throughout the year Lakewood Gardens provides wonderful photography, but autumn is best. There is no shortage of great images here, but we recommend an overcast day or early morning for best results. We prefer to arrive early, when the gates open at 10 AM, and take our time.

Lakewold is located at 12317 Gravelly Lake Drive SW, Lakewood. From I-5 take exit 124 west and follow the signs.

Lakewold Gardens: 253-584-4106; www.lakewoldgardens.org

79. Northwest Trek

Just outside Eatonville on WA 161 there is a very special safari park featuring a host of animals, large and small. Northwest Trek is located at 11610 Trek Drive East, and is an extension of Point Defiance Zoo and Aquarium.

Natural wildlife exhibits include wolves, bison, elk, grizzlies, cougars, lynx, bobcat, black bear, and more. Smaller species include wolverine, badger, and river otter. Owls and eagles are also housed here.

Photography inside the facility is welcomed, and the opportunities abound.

A few tips: The park is open from 9:30 to 6:00 daily, but try to arrive as early as possible, as some of the exhibits are in direct sun much of the day. Animals in more shaded exhibits are accustomed to visitors and perform much as they might in the wild. There is nothing more rewarding than capturing wildlife in the wild, but Northwest Trek is definitely the next best thing.

Here is a wonderful place to practice peak of action, expression, and metering of different lighting conditions.

Northwest Trek Wildlife Park: 360-832-6117; www.nwtrek.org

80. Olympia, State Capitol and Surrounding Attractions

In 1889 when Washington was finally granted statehood, a mere 357,232 people lived within its borders. Today its population is about 6 million. Much of that growth is chronicled in a variety of museums, libraries, and chambers situated throughout Olympia and the State Capitol complex. No place better speaks to Washington's unique history or provides the photographer a chance to record specific elements of it.

Washington Tourism Alliance:
www.experiencewa.com

81. Nisqually National Wildlife Refuge

Nisqually National Wildlife Refuge is located 8 miles east of Olympia at 100 Brown Farm Road NE, and is a prime location for sprawling wetlands and the wild critters they attract. The refuge includes 8 miles of trails. The birds and wetlands are our primary reason for visiting Nisqually; however, tidal flats and views of Puget Sound are also available.

Most of the National Wildlife Refuges in Washington attract a wide variety of birds both migratory (sandhill crane) and residential (blue heron). The 3,000-acre Nisqually refuge, fed by Mount Rainier's Nisqually Glacier, attracts a host of wintering waterfowl along with 200 smaller bird species.

Longer lenses are helpful for photography here, but in a popular area like Nisqually you will find birds somewhat habituated to human activity, which works to your favor.

Nisqually National Wildlife Refuge:
360-753-9467;
www.fws.gov/refuge/nisqually

82. Mima Mounds Natural Area Preserve

If you're interested in photographing unusual natural sights, a stop at Mima Mounds Natural Area Preserve will be rewarding. The chief attraction at this 450-acre preserve is a series of large grass-covered mounds some 6 feet high and 30 feet round. The origin of the mounds remains a subject of dispute among experts. Theories range from Ice Age relics to the work of frost or busy rodents. Regardless, the mounds are fascinating to photograph. Here is a site to work on unique compositions. Try strong sidelight to emphasize the size and shape of the formations.

The preserve is managed by the Department of Natural Resources and is located 12 miles south of Olympia.

Department of Natural Resources,
Forest Resources and Conservation:
360-902-1600

Washington Tourism Alliance:
www.experiencewa.com

83. Julia Butler Hansen Refuge for the Columbian White-Tailed Deer

If you are an avid wildlife photographer, you probably already know that the Columbian white-tailed deer almost became extinct. The Columbian whitetail is a subspecies of the more common white-tailed deer. In 1972 the refuge was set aside to provide sufficient habitat to increase Columbian white-tailed population.

For the photographer, the refuge offers a variety of natural settings ranging from wetland to woodland, and a host of wild species including Roosevelt elk, river otters, and a large array of birds. Located at 46 Steamboat Slough Road, Cathlamet, the refuge is a wonderful place for both wildlife and landscape photography. Morning or late evening is best. Autumn and spring are prime.

Julia Butler Hansen Refuge: 360-795-3915;
www.fws.gov/jbh

84. Columbia River Gorge Scenic Byway, Beacon Rock State Park

The west end of the Columbia River Gorge, although busy, has a number of rewarding sites for photography, particularly from Camas to Stevenson, where the Pacific Crest Trail crosses the gorge.

Beacon Rock State Park is also a good site

Smith Creek Overlook is a prime location for atmospheric morning clouds. Plan to be on site before first light.

for photography. Named by explorers Lewis and Clark, this 865-foot volcanic plug offers one of the best overall views of the Columbia River Gorge. Both sunrise and sunset from the summit are captivating. For sunrise, get an early start: the hike to the top is steep and slow. We have found no better photographic vantage point for the gorge. If you make the trip, take along a polarizing filter to eliminate haze.

Beacon Rock State Park is located at milepost 35 on WA 14.

Beacon Rock State Park: 509-427-8265

Washington Tourism Alliance: www.experiencewa.com

85. Mount St. Helens National Volcanic Monument

Of the five active volcanoes in Washington, Mount St. Helens is by far the best known after its cataclysmic eruption in May 1980. The eruption leveled 230 square miles of forest and killed 57 people.

There are simply no words to express the unsettled feeling still present at Mount St. Helens, located in the Gifford Pinchot National Forest. Two of our favorite overlooks are **Smith Creek** and **Windy Ridge**, located on WA 131 south of Randle.

Smith Creek Overlook is especially productive for morning shots. From this location you can view Oregon's Mount Hood to the south and Mount Adams to the east. For an image of Mount St. Helens's huge crater, consider the Windy Ridge Overlook. Mount St. Helens is presently 8328 feet high and a mere 300,800 years old.

Mount St. Helens National Volcanic Monument: 360-449-7800; www.fs.fed.us/gpnf/mshnvm

86. Mount Adams

This picturesque volcanic dome rises an impressive 12,276 feet and is 460,000 years old.

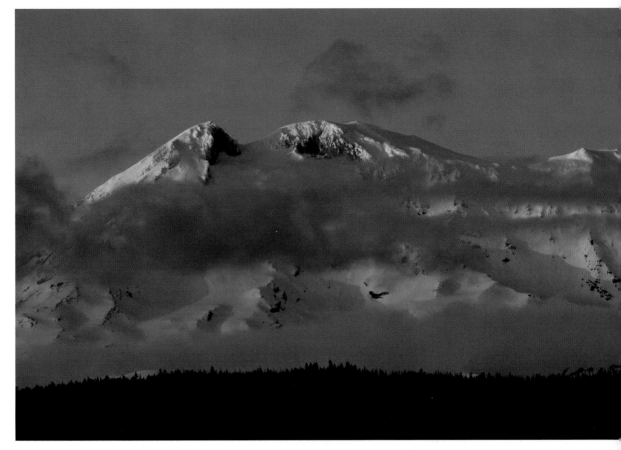

Early spring is a great time to photograph Mount Adams. We like to be north of Trout Lake at first light.

Its most visible cone is less than 40,000 years old, a blink of the eye in geologic time.

Mount Adams is situated 34 miles east of Mount St. Helens in the Gifford Pinchot National Forest, and is the crown jewel of Mount Adams Wilderness Area. Mount Adams retains snowpack year round, and is one of the most beautiful summits in the Cascade Range to photograph.

A few of the best locations you'll find for pictures of Mount Adams are on Forest Road 23 north of the town of Trout Lake. WA 141 travels from White Salmon to Trout Lake; the easiest way to find FR 23 is to stop at the Trout Lake gas station and ask directions. Mount Adams as viewed from the Takhlakh Lake Campground area is fabulous, but there are several other vantage points along the way.

Mount Adams Chamber of Commerce: 509-493-3630; www.mtadamschamber.com

87. Lewis River

The Lewis River ranks among the most beautiful in Washington. It is accessible from WA 503. At the town of Cougar, turn on Forest Road 90 and continue to the head of Swift Lake, where the river enters. From there continue on FR 90. There are a number of access points as you follow the river, including a se-

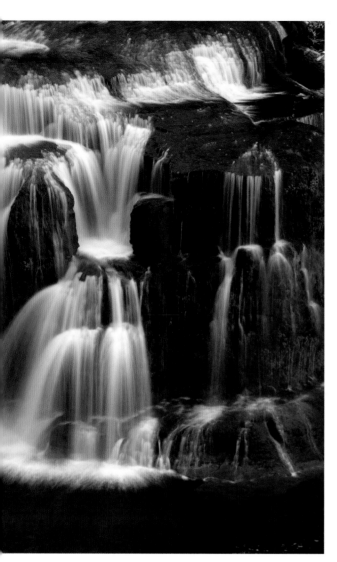

We photograph Lewis Falls in mid to late August, when water levels drop.

ries of outstanding waterfalls: Lower, Middle, and Upper Lewis River Falls (site 88). For a more intimate photographic experience, consider the 14-mile Lewis River Trail, accessible from the Lewis River Trail.

Mount Adams Chamber of Commerce: 509-493-3630; www.mtadamschamber.com

88. Lewis River Falls

Among the waterfalls beyond Swift Lake, Lower, Middle, and Upper Lewis River Falls are our personal favorites, with Lower being the best. You'll want to plan your trip carefully, however. To begin with, the road along this part of the Lewis River is closed in winter. In spring and early summer, the falls are gushing with runoff and less approachable and photogenic. Mid-August, after water level drops, the falls are spectacular.

There are a couple of good overlooks on the forested ridge above Lower Falls, but we suggest pursuing the "river access" beyond the last downstream overlook. By August, the river is shallow enough to wade toward the falls. Evening in shadow, or early morning, are best for photography, to avoid distractive hot spots. Remember, the water cascading over the falls is moving fairly swiftly, so if you use a slow shutter speed, be careful not to clip highlights in water areas. Consult the histogram to make sure enough detail is recorded in these areas. You can't create detail later during processing.

Mount Adams Chamber of Commerce: 509-493-3630; www.mtadamschamber.com

89. Glenwood Loop Scenic Byway

This 100-mile drive travels from Bingen to Trout Lake to Glenwood to Lyle, and back to Bingen, and covers some spectacular country.

The route departs on WA 141 at the Columbia River Gorge and travels along the Wild and Scenic White Salmon River to Trout Lake. Turning east, the loop follows a back road to Glenwood. Beyond Glenwood the road eventually rejoins WA 142 bound for Klickitat, where it then follows the Wild and Scenic Klickitat River south to Lyle. Eventually WA 14 returns to Bingen.

Along the route there is plenty of opportunity to photograph; occasionally Cathie and I

will spend the day exploring side roads along the way.

Mount Adams Chamber of Commerce: 509-493-3630

Klickitat County Information: www.klickitatcounty.org

90. Columbia River Gorge

Traveling along the Columbia River Gorge, especially on a cloudy morning, can yield an array of wonderful photographs. We like to select a pull-off with a rugged shoreline and wide view of the river. The gorge and the river are fascinating when storm clouds finally pull apart, but you have to anticipate the right moment to take a picture. The gorge is most atmo-spheric on days like this. The light is generally soft enough to be fairly consistent. We'll use a white balance a little warmer than usual just to add some color in the highlight areas. Keep a close eye on the background.

Columbia River Gorge Visitors Association: 800-98-GORG; www.crgva.org

91. Conboy Lake National Wildlife Refuge

Wildlife, landscape, and pastoral scenes are all available at Conboy Lake National Wildlife Refuge. On a clear day, this beautiful 6,532-acre refuge serves as a backdrop for Mount Adams. But the refuge itself is one of the most impressive on the Columbia Plateau. It is

Interesting cloud cover makes for a dramatic landscape shot.

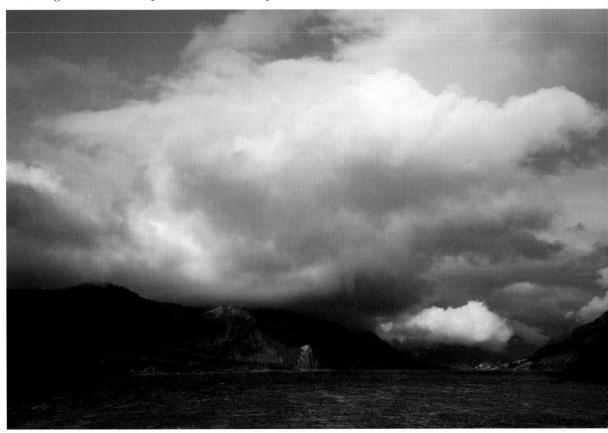

home to a long list of migratory birds including swans and ducks. Elk, coyote, black bear, and beaver are also present.

Conboy offers a 2-mile trail as well as refuge roads. Like many National Wildlife Refuges, it mixes remote wildness with a strong sense of human history. The hand-hewed log home of John Cole, built in 1891 to house his family of seven, was moved to the refuge from 2 miles away and stands as a reminder of early pioneer life, set amid beautiful surroundings. For wildlife, early morning and late afternoon are best. There are a number of self-guided trails in the area, so save some time to explore.

Conboy Lake National Wildlife Refuge: 509-364-3667; www.fws.gov/conboylake

Photographs capture Washington's rich human history.

92. Gifford Pinchot National Forest

A slow morning trip through the Gifford Pinchot National Forest on WA 504 will introduce you to Washington's abundant elk. On most mornings, small herds can be seen and photographed in meadows adjacent the road. We like to amble through this part of Washington early to late June when young spotted calves are out. A longer lens can be helpful, but truly, here we do very well with a 300mm.

Mount Adams Ranger District: 509-395-3400

Washington Tourism Alliance: www.experiencewa.com

93. Mount Rainier

Not enough can be said about the year-round photographic opportunities available in Mount Rainier National Park (site 95). The 14,411-foot Mount Rainier is the tallest peak in Washington, and aside from being a beautiful mountain it is also an active volcano. The mountain is a marvel to photograph, as it appears to change dramatically depending on the photographer's vantage point, the weather conditions, and the time of day.

Some of our favorite places to catch the mountain include Paradise, Reflection Lakes, Tipsoo Lake just west of Chinook Pass, and of course from Sunrise Point. There are also a number of other vantage points we seem unable to ever pass up, like the popular pull-off along Mather Memorial Parkway, WA 410 between Cayuse Pass, and the turnoff to Sunrise Point. With just a few days' experience, you'll have a list of your own favorite vantage points.

When we set out to photograph Mount Rainier our aim is to come away with something different; after all, it ranks among the most photographed sites in the Pacific Northwest. In striving for something beyond just

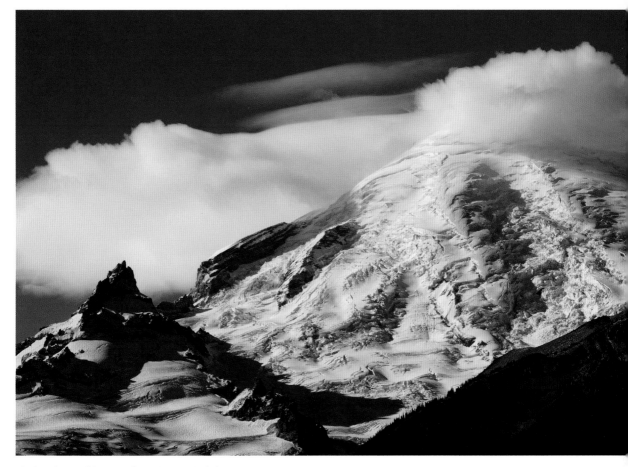

An iconic Washington shot: Mount Rainier.

another traditional image of this spectacular mountain, one advantage you'll have is the fact that the mountain creates its own weather, and every morning it awakens to a different mood and changes dramatically throughout the day depending on the sky above its crest. With this in mind, we try to include as much interesting weather and unusual light as we can. We try to blend these elements into our images, and in some cases even make them the central point of interest. We think this approach helps our work stand out.

Mt. Rainier Visitor Association: 360-569-0910; www.mt-rainier.com

94. Mount Rainier from Tipsoo Lake

Just beyond the summit of Chinook Pass, WA 410 enters Mount Rainier National Park and descends to the valley below. A short distance from the entry point, you will see a long, narrow pull-off and sidewalk on the right side of the road. Below is Tipsoo Lake, and off in the distance is Mount Rainier. This vantage point is one of our all-time-favorite spots from which to photograph the mountain at first light. As a matter of fact, the photograph on the cover of this book was taken from that very spot.

There are two great shots of the mountain here. The first, more traditional shot includes

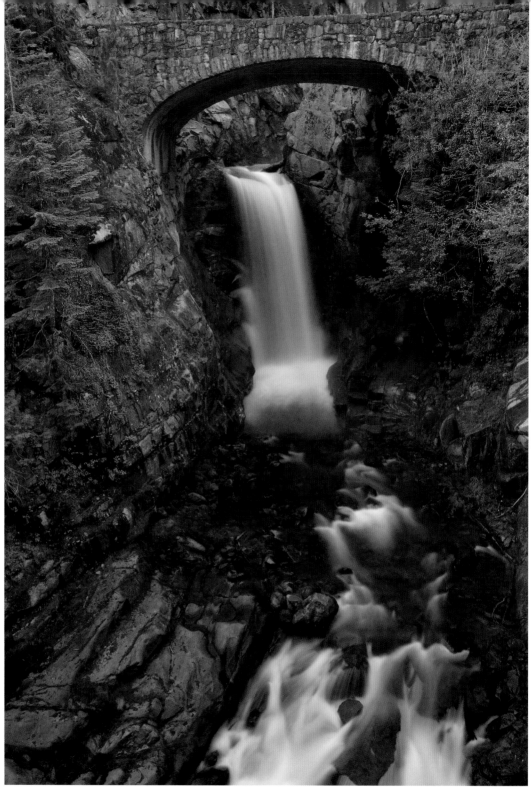

To avoid deep contrast and hot spots, render Christine Falls under an overcast sky.

Tipsoo Lake as a foreground. Most mornings however, we choose a different approach at first light. We use a longer lens (100mm to 200mm) to isolate the mountain and emphasize morning cloud formations and colorful mist. The tooth-like ridge in front of the mountain gives it an unusual appearance, which is generally what we are looking for. Once light reaches the lake, we rely on an entirely different composition, with the lake as a foreground. For both shots, a tripod and remote release are important. Incidentally, we also lock up the mirror in the camera to avoid the slightest vibration.

Mt. Rainier Visitor Association: 360-569-0910; www.mt-rainier.com

95. Mount Rainier National Park

Surrounding Mount Rainier is one of the country's most interesting and abundant ecosystems, in large part created by the mountain itself. The wonderful terrain around Mount Rainier abounds with photographic opportunity, as evidenced by the myriad waterfalls, wildflower meadows, streams, and lush forests. Here we offer a summary of what awaits the photographic eye.

Wildflowers. The peak time for wildflowers in Mount Rainier National Park spans mid-August to mid-September. The higher you get, the later the season. Some of our favorite wildflower spots include meadows at Sunrise Point; nature trails at Longmire; the Wonderland Trail; Paradise to Camp Muir; Tipsoo Lake area; and the summit of Chinook Pass.

We always use a short tripod for wildflowers, whether we're shooting them close-up or as a foreground in a larger landscape. If it's breezy we select a fast-enough shutter speed and ISO to make absolutely sure we freeze movement. On close-ups, we use macro lenses, 55mm and 100mm, generally mounted on a focusing rail.

Waterfalls. We enjoy photographing several waterfalls at the park, which are quite accessible, being close to the road. These include Christine Falls, which we shoot in morning and evening under low light or shade, and Sunbeam Falls, which we shoot after the water level has dropped and flowers are out. For us, this is an early-morning shot when the light is low and mountain air has not yet generated a gentle breeze. Early to mid August is best.

Narada Falls can be a devil to shoot. In spring, there is just too much water cascading over it to photograph effectively. We generally wait until mid-August to consider a shot. Early morning is best, because hotspots later in the day will ruin your photographs. Here we concentrate on low light, which, by the way, will also emphasize the falls and separate it from the rich foreground. The lower overlook is best.

Silver Falls is a mid- to late-spring subject for us. It is best when water level is sufficient, but not roaring. Autumn is also special for color around the falls. Comet Falls yields the best results in midsummer to autumn. A combination of diffused light and slower shutter

Colorful flowers and vegetation abound in wilderness areas. Bring a macro lens along for the hike.

speed is particularly effective here. Avoid direct light.

For smaller waterfalls in Mount Rainier park, we find June to be best, simply because many picturesque falls along the road only flow or flow best during mountain runoff.

Streams and Creeks. Nickel Creek and Sunbeam Creek are among our favorite subjects in early summer and autumn.

Warm evening light sparks this image to life.

Day Hikes. Among our favorite day hikes are Paradise Park in August; Wonderland Trail from Box Canyon; Comet Falls from Christine Falls; Green Lake Trail; and Silver Falls Loop. Reflection Lakes (2.75-mile loop trail) are truly awesome and not to be missed.

Be on site early, well before sunrise, to find the perfect spot.

Mount Rainier Visitor Association: 360-569-0910; www.mt-rainier.com

96. Goat Rocks Wilderness

Goat Rocks Wilderness is situated between White Pass on US 12 and the north-facing slopes of Mount Adams. The wilderness encompasses 105,600 acres. Trails lead into the interior from both sides of the wilderness, and we highly recommend it for day hikes. A tip: it was named after mountain goats common to the area.

Washington Tourism Alliance: www.experiencewa.com

97. Coastal Harbors

Some of Washington's richest human history comes from the bounty of the sea, and man's reliance on the sea for food and subsistence.

There is a feeling of the "old ways" present around Washington's southwest harbors that can inspire award-winning photographs. Cathie and I find harbors among the most intriguing places to photograph. We tend toward warm morning light right after sunrise, old boats with descriptive names, interesting gear, and close-up shots. We also like reflections, foggy days, and ropes tied in strange knots. It's easy sometimes to get swept away by the grand natural beauty of Washington, and miss some of the smaller scenes that make this state artistically wonderful. A few of our favorite harbors are: Grays Harbor, La Push Harbor, and Ilwaco.

Washington Tourism Alliance: www.experiencewa.com

Kites stream across a clear blue sky.

98. Long Beach

Located at the mouth of the Columbia River, Long Beach runs 30 miles from the river to Leadbetter Point. It is thought to be the longest sand beach in America. The beach was created by sediment carried down the Columbia and pushed north on strong Pacific currents over millions of years. To the west, the Pacific Ocean pounds its shore, constantly shifting sand from one place to another. To the east, calm Willapa Bay rests. Almost the entire western shore consists of beautiful sandy beach, and serves as a wonderful foreground for crashing Pacific waves.

One of the best locations to photograph the beach is Discovery Trail, which travels 8 wonderful miles between Ilwaco and Long Beach.

Distant shots of Long Beach will be enhanced by a polarizing filter, used to reduce haze and deepen color. Try a series of slower shutter speeds to produce just the right effect.

Long Beach Peninsula Visitors Bureau: 360-642-2400; www.funbeach.com

99. Washington State International Kite Festival

Held each year during the final week of August in Long Beach, the Washington International Kite Festival is a great event to photograph. The festival includes both competition and celebration and abounds with creativity, camaraderie, and more kites in the air than you can imagine.

Along with the bright colors streaming across the morning sky are the devotees who come to fly the kites. This is a fun festival to photograph and might just get you hooked on the festive pastime of kite flying. Make reservations early if you plan to attend.

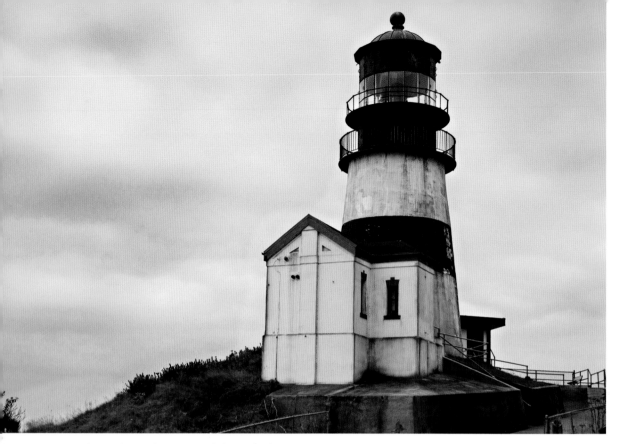

Cape Disappointment Lighthouse makes for an evocative photographic subject.

Washington State International
Kite Festival: 360-244-0669;
www.kitefestival.com

100. Cape Disappointment State Park

Cape Disappointment State Park is located 2 miles south of Ilwaco on WA 100. It is here the mighty Columbia River finally meets the ocean.

The 1,880-acre park features 27 miles of rugged shoreline, old-growth forest, sandy beach, tide pools, and plenty of wildlife. It is the most visited park in the Washington system, so plan to have company if you photograph here. This is a striking spot for beach-combing pictures.

Long Beach Peninsula Visitors Bureau: 360-642-3078; www.funbeach.com

101. Cape Disappointment Lighthouse

Cape Disappointment Lighthouse is one of the oldest on the Pacific Coast and beautiful to photograph. We prefer sunset or late-afternoon illumination when working here. Sunrise with clouds also yields lovely images.

Long Beach Peninsula Visitors Bureau: 360-642-3078; www.funbeach.com

102. Leadbetter Point State Park

Located 18 miles north of Longbeach, Leadbetter Point State Park falls just short of the very tip of Longbeach. Trails wander along 4 miles of woodland, beach, sand dunes, and wild bunchgrass. Because few tourists wander this far, Leadbetter Point is a good place for beach shots accented by wild foregrounds.

Long Beach Peninsula Visitors Bureau: 360-642-3078; www.funbeach.com

103. Old Fort Canby

Established in 1863, Fort Canby is particularly interesting photographically. The old buildings speak to the early maritime history of Washington.

Washington State Parks, information center: 360-902-8844

Washington Tourism Alliance: www.experiencewa.com

104. North Head Lighthouse

The Columbia River Bar is one of the most dangerous water passages on the West Coast, which accounts for the remarkable North Head Lighthouse. It was built in 1856 as a result of hundreds of shipwrecks in what seafarers once called the graveyard of the Pacific. Some of the wreckage is still visible in Washington today. The lighthouse is a great photographic subject under afternoon low-angle light, and can't be beat at sunset.

Long Beach Peninsula Visitors Bureau: 360-642-3078; www.funbeach.com

North Head Lighthouse, at the mouth of the Columbia River.

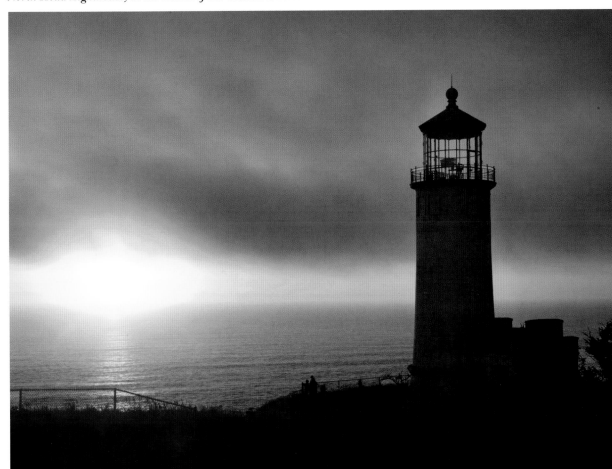

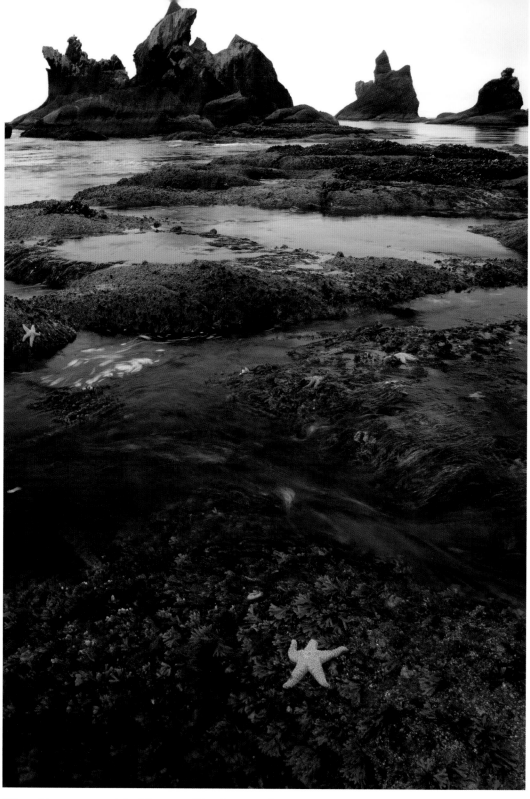

When skies are overcast, look for compelling foregrounds.

V. The Coastal Regions

Earlier we discussed the varied Pacific terrain and islands that migrated east to join the work in progress that is today's Washington. As we look at a current map of the state, it is possible to trace what actually occurred millions of years ago, simply because resting off Washington's mainland are hundreds of islands, spits, peninsulas, and other landforms that might one day be firmly attached to the West Coast, evidence of the truly unsettled nature of this wild and wonderful landscape.

105. Cranberry Coast

Cranberrys are cultivated in bogs along the coast of Washington and Oregon alike. The whole business started generations ago when a visitor from Massachusetts spotted wild berries growing in Washington wetlands. Today it is a big business, and the colorful bogs are wonderful to photograph.

At 2907 Pioneer Road in Longbeach you'll find both a museum and a demonstration farm where you can get a photographic taste of cranberries at their best.

Cranberry Coast Chamber of Commerce: 360-267-2003

Pacific Coast Cranberry Research Foundation: 360-642-5553; www.cranberrymuseum.com

106. Bloedel Reserve, Bainbridge Island

This serene property gives visitors access to a wonderful Japanese garden, meditative Zen garden, tranquil reflection garden, and others. The reserve also features a wonderful bird refuge that includes trumpeter swans, and a French-style mansion that is open to the public. The reserve prides itself on harmony and tranquility, and these qualities transfer to images captured here. It is located at 7571 NE Dolphin Drive, Bainbridge Island, and is open year round Tuesday to Sunday 10–4.

Bainbridge Island Chamber of Commerce: 206-842-7631

Bloedel Reserve: 206-842-7631; www.bloedelreserve.org

Along the Pacific Coast Scenic Byway

107. Sequim Lavender Festival

The small town of Sequim, located a short drive east of Port Angeles, is home to some of Washington's most colorful lavender farms. Each season the community hosts a lavender festival, which is an outstanding photographic outing.

Of the several farms in the area, Purple Haze and Jardin du Soleil Lavender are our favorites. Colorful and nicely landscaped, all the farms in

A slight breeze is common to this part of Washington. Use a quick shutter speed to stop any motion.

the Sequim area are worth a visit. We prefer to shoot lavender early in the morning under strong sidelight to emphasize color. The wind, which oftentimes frequents this coastal region, is typically less of an issue in the morning. Low sidelight is also prime for the use of a polarizing filter, which helps saturate rich color.

The festival is usually scheduled during the third week of July.

The Point Wilson Lighthouse is great for cloudy-morning shots.

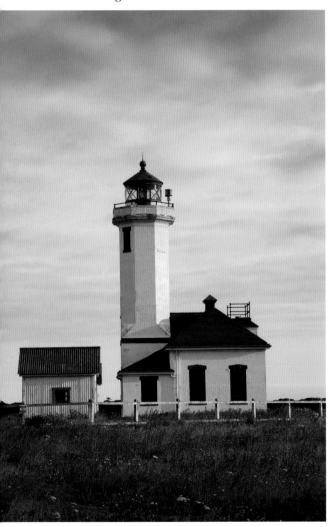

Sequim Chamber of Commerce: 360-683-6197; www.sequimchamber.com;

Sequim Lavender Growers Association: www.lavenderfestival.com

108. Port Townsend and Fort Worden State Park

The charming Victorian town of Port Townsend, founded in 1851, is located at the northeast tip of the Olympic Peninsula. It boasts one of the largest collections of Victorian homes and commercial buildings on the peninsula. A short list of these historic properties includes the Rothschild House, the John Quincy Adams House, and the Hastings Spec House, among others built by successful business leaders, merchants, and sea captains. The buildings are a thrill to photograph.

Also in the area is Fort Worden State Park, featuring the many buildings of old Fort Worden as well as the Point Wilson Lighthouse—all overlooking the picturesque Strait of Juan de Fuca.

The buildings in town are better shot under warm, early light. If the Point Wilson Lighthouse inspires you, we suggest arriving before dawn so you can gauge the best time and angle for sunrise shots. A split neutral-density filter will help balance dynamic range at the lighthouse. Don't feel shy about bracketing in full f-stops to get just the right effect.

Jefferson County Chamber of Commerce: 888-ENJOYPT; www.ptguide.com

109. Port Angeles

The coastal town of Port Angeles is not only one of the state's most attractive towns, it serves as a northern gateway to Olympic National Park. Park headquarters is located here, as is the entrance to Hurricane Ridge. The ridge is a mountain and wildflower paradise under the right conditions. One of our favorite shots in the entire state of Washington

can be taken here almost every morning, on the ridge overlooking Port Angeles and the Strait of Juan de Fuca.

Because of the strait's moisture, the lowland in which Port Angeles is located is oftentimes completely covered by low-hanging clouds. Catch this awesome sight from the second large pull-off inside the park on Mount Angeles Road, but be there before sunrise so you can feast on the outrageous light as it develops. There's nothing better than shooting a colorful sunrise from above the clouds. A tripod is a must.

Olympic National Park: 360-565-3130

Washington Tourism Alliance: www.experiencewa.com

Traveling West–Southwest from Port Angeles

110. Marymere Falls

A short hike from the parking lot at Lake Crescent leads to one of Olympic National Park's foremost waterfalls. From a sheer rock wall, Marymere Falls tumbles 90 feet into a mist-drenched cavern below. It can be photographed in its entirety from an overlook provided for visitors. The waterfall is usually in shade, thus requiring slow shutter speeds and a tripod. In this location you can use high contrast to your benefit. Water volume over the falls varies depending on the time of year. We always allow the falls to stream past a long shutter, creating a more veiled appearance, which contrasts nicely against the dark background. There is plenty of green along the falls to add sufficient color.

A common mistake at sites like Marymere Falls is to leave with just a few images. We bracket a lot in these settings, usually in half-stop increments, and we always work the scene almost to exhaustion by isolating certain

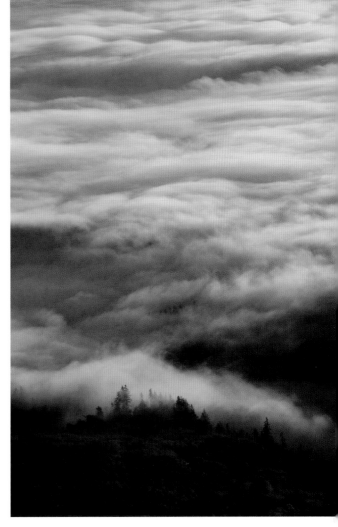

Morning fog extends along the valley and Strait of Juan de Fuca, concealing Port Angeles.

smaller sections or advancing ISO to create a different effect.

Olympic National Park: 360-565-3131; www.nps.gov/olym

111. Olympic National Park

When you review the images from your first complete photographic tour of Washington, no doubt one word will come to mind: "diversity." You'll have high mountains, arid eastern plains, a fantastic basalt-lined gorge, rugged

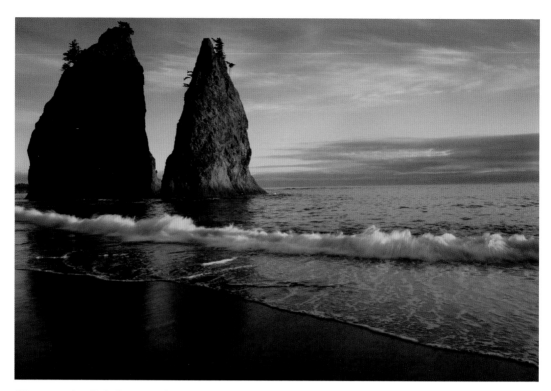

Warm evening light bounces off incoming waves.

coastlines, fertile valleys, fertile farm ground, and miles of sandy beaches. Olympic National Park is sort of like one-stop shopping for all that Washington has to offer.

A quick reference for photography inside Olympic National Park might include the following. For beaches and coastal scenes, consider Ozette, Mora, and Kalaloch. For grand mountains and glaciers, Hurricane Ridge and the Olympic Mountains; and for lush forests, waterfalls, and gushing streams try Elwha, Sol Duc, Dosewallips, and Staircase to the east, and Hoh and Quinault to the west.

Photographically, Olympic National Park is, in our opinion best in spring and autumn, but be prepared for rain during both seasons. Deciduous color peaks in October. Here are a few select places we never pass by when we travel the Olympic Peninsula:

Hurricane Ridge. Plan to spend considerable time here, beginning your photographic day before sunrise. A special place for us is the second pull-off on the road to Hurricane Ridge Visitor Center. The pull-off overlooks the valley and the Strait of Juan de Fuca. Most mornings the scene is carpeted by a thick layer of fog, which is absolutely mind-blowing at sunrise.

Elwha Valley and **Madison Falls** are breathtaking in autumn, less so in spring and summer. Morning or overcast days are best.

Sol Duc Falls is challenging to photograph. Use diffused light, be careful of distracting hot spots, and avoid very slow shutter speeds. Make sure to record sufficient detail in highlight areas. The small mossy creek a short distance before the falls is a wonderful place to isolate smaller scenes.

Ruby Beach, Beach One, Beach Two, Beach Three, Beach Four. Remarkably, each Olympic beach has a unique character. We like sunset shots here, and always look for an unusual foreground to provide depth to colorful backgrounds. We commonly use tide, waves, and breakers as an interesting starting point. The entire hour before sunset on the Olympic beaches is especially beautiful due to the low angle of light. Look for inspiring backlit water, waves crashing on rocks, and rich, colorful light on shorelines.

Quinault Rain Forest and **Hoh Rain Forest**. Rainforest photography is best under diffused light or just before the sun causes distracting hot spots. Bright sun and hot spots add chaos to forest scenes. Early morning works best, with overcast days also effective. The waterfalls in the Quinault area rank among our all-time fa-

vorites. They are surrounded by plenty of vegetation, and dark, shiny rocks and moss provide interest and depth. Some waterfalls separate into different strands, adding more interest. Here you really need to avoid bright light and distracting hot spots. A tripod is a must.

Olympic National Park by any standards is immense and diverse. If you plan a trip here, make sure it is during an optimal season for photography, and give yourself plenty of time to explore. Take one attraction at a time: beaches for a couple of days, rainforests for a couple more, etc.

Olympic National Park: 360-565-3131; www.nps.gov/olym

112. La Push
La Push is situated on the Quileute Indian Reservation and surrounded by Olympic

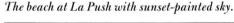

The beach at La Push with sunset-painted sky.

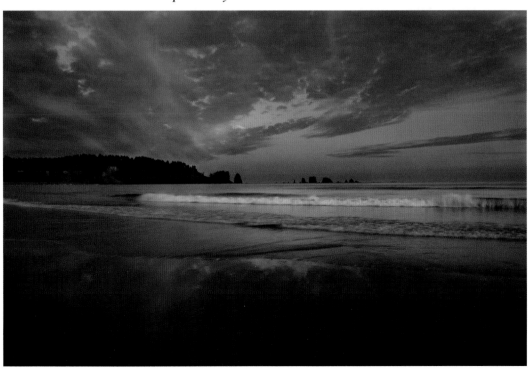

National Park. It has a truly fine beach for sunsets. To get to the beach, enter La Push and thread your way west. Effective foregrounds include sea stacks to the west and sandy beach to the south. While you're searching for a foreground, notice the great tree west of the parking lot. This is a favorite spot for locals, so plan on company as you photograph.

For many of our beach sunsets and sunrises, we use Tiffen graduated neutral-density filters to balance shaded foreground and bright background. High dynamic range (HDR) also works, but most of the time we find it less troublesome to extend dynamic range with filters.

La Push is another spot where bracketing may save the day, particularly on the south beach where wave action on dark sand might attract your eye. We find bracketing in full stops is enough on beach scenes. Remember, sunsets and sunrises are more powerful when they are elements of a greater scene.

Washington Tourism Alliance: www.experiencewa.com

113. Wilderness Surrounding Olympic National Park

Washington holds such appeal to nature lovers and nature photographers in large part because

For a more private experience on the Olympic Peninsula, consider the wilderness areas surrounding Olympic National Park.

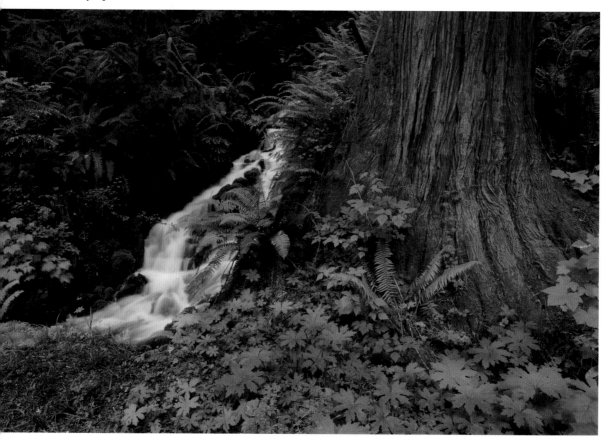

of its longstanding commitment to wilderness, which in most cases surrounds national parks. Olympic National Park is no exception.

On the eastern border of Olympic National Park you'll find Buckhorn, Colonel Bob, The Brothers, and Mount Skokomish Wilderness Areas. Hugging the park's southern border you'll find Colonel Bob and Wonder Mountains Wilderness Areas.

These areas represent the natural world at its best, untouched by human development. They offer unique and wonderful photographic opportunities for those undertaking either long extended hikes or shorter day hikes. Designated wilderness is managed by the U.S. Forest Service, which has detailed maps and volumes of useful information. The Wilderness Areas are a true compliment to Olympic National Park.

Washington Tourism Alliance:
www.experiencewa.com

Traveling Northwest from Port Angeles

114. Northern Coast, Strait of Juan de Fuca

A few miles west of Port Angeles, WA 112 heads to Neah Bay and Cape Flattery, representing the most westerly point on the North American map. At first the highway twists through dense forests and finally finds its way to the northern coast of the Olympic Peninsula where it overlooks the Strait of Juan de Fuca.

When planning a morning trip to the cape, we always time things so we are traveling the coast when the sun comes up. This strategy has helped us compile a wonderful collection of coastal scenes from the area. There are plenty of pull-offs providing access to the morning shooter. Several include rugged foregrounds for a side-lit sunrise. If you're in the right place at the right time, the setting is su-

Wild sunrise images are enhanced by detailed foregrounds.

perb. Plan to arrive along the coast before the sun comes up.

Washington Tourism Alliance:
www.experiencewa.com

115. Neah Bay

Entering the fishing village of Neah Bay feels like taking a huge but pleasurable step back in time. The more time you spend here, the more you'll appreciate the people and their slower pace. Located in the heart of the Makah Indian Reservation, the town breathes history; this is

Part of what makes Washington a great photographic venue is its rich Native American history.

a way of life fast disappearing in other parts of our busy world.

To capture that sense of place and time with a camera is a truly enjoyable challenge, one that might begin at the Makah Cultural Center, along WA 112 as you enter town. In Neah Bay you can purchase a recreation permit for $10, which allows you to visit and photograph Cape Flattery and Shi Shi Beach. Permits are available at the Makah Cultural and Research Center, Washburn General Store, Makah Tribal Center, and Makah Marina.

Makah Cultural and Research Center: 360-645-2711; www.makah.com/mcrchome.html

116. Cape Flattery

Cape Flattery, in our opinion, is one of the most powerful natural scenes in Washington. It is located on the Makah Indian Reservation and renowned for rugged coastal scenes.

The cape is actually the farthest western point on the map. The .75-mile trail leading to the cape is well maintained and includes large boardwalk sections threading through a moist coastal landscape and finally arrives at sturdy overlooks. One of the first overlooks features coastal caves highlighted by white breakers below. Other overlooks present more expansive coast scenes, accented by rich color especially in diffused light.

The creative key here is to intensify mood through the dramatic use of light. The area is best rendered under diffused light and slow shutter speeds. We use a polarizing filter to saturate color.

Tatoosh Island just off the cape is sacred to the Makah people. From the tip of Cape

Flattery south to Ozette, the Flattery Rocks National Wildlife Refuge dominates the beautiful coast line.

Makah Cultural and Research Center: 360-645-2711; www.makah.com/mcrchome.html

117. Shi Shi Beach

Few beaches in Washington can match this spot for photography. The trail to Shi Shi begins on the Makah Indian Reservation and the town of Neah Bay, where a tribal recreation permit can be purchased.

Shi Shi Beach was added to Olympic National Park in 1976, but for generations it was treasured by Native American bird-watchers, hikers, and surfers. Now open to the public, few places around can match it. A well-worn trail travels through ancient Sitka spruce, down some steep embankments, and finally ends on the spectacular beach. Low tide is our favorite time on Shi Shi for both beach and tide-pool scenes The pools are filled with ocean life and make wonderful foregrounds.

To reduce glare on the surface of tide pools, try a polarizing filter, which will also heighten underwater color. The hike to Shi Shi Beach is 8 miles round trip, with an elevation gain of 1,000 feet.

Makah Cultural and Research Center: 360-645-2711; www.makah.com/mcrchome.html

The rugged northwest coast is best photographed under balanced light.

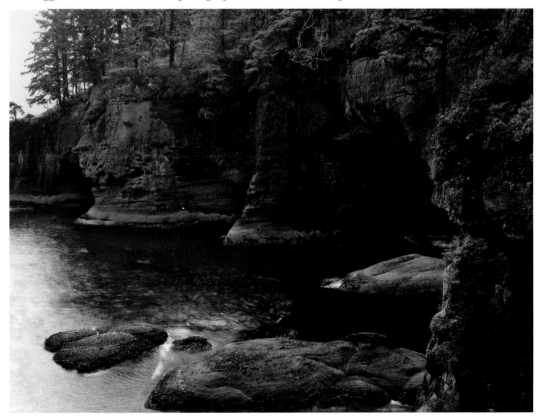

Other Great Coastal Regions in Northern Puget Sound

118. San Juan Islands

Photographing on the San Juan Islands is a rare pleasure. They are located between the Strait of Juan de Fuca and the northerly Strait of Georgia, and are gems in the natural crown of Washington. There are actually 172 named islands in the San Juan archipelago, among which the Washington State Ferry system serves four: San Juan, Orcas, Lopez, and Shaw, from Anacortes. Lummi Island is served by a county ferry from Bellingham, while Guemes Island is reached via a county ferry from Anacortes.

Like much of Washington's northwest, the San Juan Islands have a solid agricultural history going back generations, and offer plenty of pastoral scenes. The rugged coastline shared by the islands will also catch the photographic eye. Orcas and Lopez Island are our personal favorites. Ocean sunsets and sunrises are special here, and areas such as Shark Cove on Lopez Island and the more secluded coastal spots command much of our attention. Among the many subjects to photograph in the San Juan archipelago are whales just off the coast.

Strong detail adds depth to a nature portfolio.

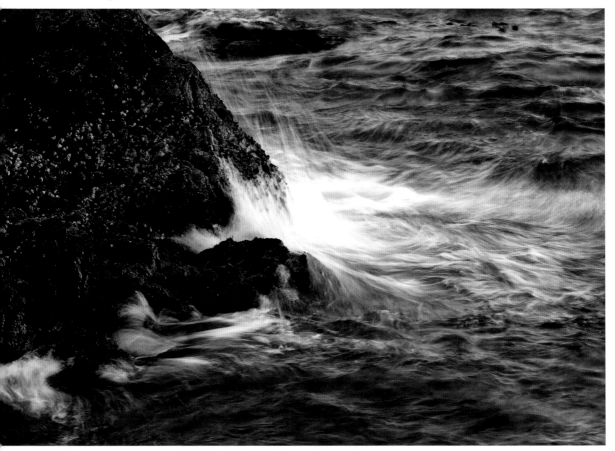

There are any number of commercial charters that serve whale watchers and photographers.

Accommodations on the islands are plentiful and include campgrounds. One of our favorite San Juan Island experiences is Lopez Island in autumn.

San Juan Island Chamber of Commerce: 360-378-5240; www.sanjuanisland.org

119. Camano Island

Located between Whidbey Island and the mainland, Camano Island is a prime destination for bird photography, not to mention beaches and a couple of lovely parks and reserves (Camano Island and Cama Beach State Parks, English Boom Historical County Park, Four Springs Lake Preserve, and Iverson Spit Waterfront Preserve, among others).

Among the birds photographers will find here are nesting eagles, osprey, loons, and an assortment of waterfowl and songbirds. For best results, a longer telephoto lens (300 to 600mm) is helpful, particularly for smaller songbirds.

The island has a rich history. The preserves and parks in the area offer good trails for hiking and an assortment of photographic encounters.

Camano Chamber of Commerce: 360-387-0889, 360-629-7136; www.camanoisland.org

120. National Wildlife Refuges

Cathie and I are inescapably hooked on National Wildlife Refuges, for a number of reasons. They offer great history, great scenery, and, of course, access to our wild neighbors. The state of Washington has a total of 20 wildlife refuges, with diverse natural terrain from desert to coastal marine to island. All are managed by the U.S. Fish and Wildlife Service, an agency endowed with a host of experts willing

Sometimes the shot of the day lands right in front of you. Treasure the experience.

to help photographers utilize and enjoy the refuge system.

Washington's NWR sites include those easily accessible from major roads, like McNary, Nisqually, and Dungeness, as well as more remote, like Saddle Mountain, Turnbull, and Conboy. Over the years, whenever and wherever we travel professionally, we first compile a list of NWR sites to visit, and we are seldom disappointed.

For a comprehensive list of NWR sites throughout the nation, visit the headquarters of almost any NWR site and request a copy of the National Wildlife Refuge System Map, or call 1-800-344-WILD. If you're like us, the guide will be dog-eared after just a few seasons. It is a great guide to great photography.

U.S. Fish and Wildlife Service: www.usfws.gov

Every time Cathie and I return from a photographic trip, we process our files independently, delete the outtakes, and settle on the best of the best. When the processing is finished, we come together for a showing and a small glass of wine. It's tradition for us, and has been for decades. Neither of us can recall the exact number of "Wow" moments we've encountered in these showings over the years, but it seems that more than the average have come from our work in Washington. Every stop, every overlook, every beach offers one remarkable scene after another, one natural splendor after another, and each time we visit, they welcome us back and reveal something new.

For us, this is the real value of photography, and it's a realization that never fails to strike us during these early viewings of our work. Time after time we have found that nothing we do to propel our art forward is wasted, nothing is lost to the past or dismissed as imperfect or irrelevant, because in reality, it is the act of photography itself that brings us the most pleasure. Simply stated, photography for us is much more than a pastime or profession; our pictures are the result of something much bigger. They are a celebration of the beauty, history, and story all around us.

We learned something else over time, something that drives our work as nature photographers: we learned that the very first critic we need to satisfy, the first viewer we need to inspire to action, educate, or impress, is ourselves as artists. Sure we need to perfect our skills, find great new locations, and dedicate time to travel, but all that is secondary to the sincere love and concern we have for the natural world around us and our desire to help preserve it for future generations. Through our photography and books like *Photographing Washington,* we act on that love and desire and hope others will take inspiration from them.

Here's a salute to what drives you as a photographer, what inspires you, and the many things you cherish and appreciate about your own creative work. Remember, nothing in what we do as photographers is wasted along the way; it is all put to good use somewhere along the line.

We hope someday to meet you, somewhere on a sunlit day in Washington as our paths cross in this beautiful state. We hope to see you sitting quietly beside your camera, just taking it all in after the creative work is done.

Gordon and Cathie Sullivan